i never

knew

what

time

it was

for leslie
coworker in the
field of art
david

i never

knew

what

time

it was

david antin

university of california press berkeley los angeles london

University of California Press
Berkeley and Los Angeles, California

University of California Press, Ltd.
London, England

©2005 by the Regents of the University of California

Library of Congress Cataloging-in-Publication Data
Antin, David.
 I never knew what time it was / David Antin.
 p. cm.
 ISBN 0-520-24304-8 (cloth : alk. paper)—
ISBN 0-520-24305-6 (pbk. : alk. paper)
 1. Performance art—Texts. 2. California—
Civilization. 3. Arts—California. I. Title.
PS3551 .N75I15 2005
811'.54—dc22 2004018187

Grateful acknowledgment is made to the editors and
publishers of books and magazines in which some of
the selections in this volume first appeared: *108/107*,
Boston Review, *Call*, *Conjunctions*, *Fence*, *Golden
Handcuffs Review*, *Mantis*, *Radical Society*, and
Review of Contemporary Fiction.

this book is for elly

without whom

it would have been

much duller

contents

by way

of a

preface

a number of years ago i was giving a talk very much like the talks
from which the pieces in this book took their origin and i was trying
to think my way through the difficult issues of what it means in this
culture to be a professional and why i was never quite comfortable with
the term after about forty minutes of this talking and thinking
feeling i had done as well as i could for the moment i came to a
provisional ending and as soon as i was done a woman who had been
following the course of my talk with apparently intense interest rushed up
to me and said with a strong sense of relief thank god i was so afraid
youd forget your words but there were no words my talks are not
lectures theyre thinkings and meditations i come with concerns and
reflections with questions and matter for thinking even obsessions
but there are no words not ahead of time

i could use the word "improvisations" ive used it before but ive
come to distrust what most people think it means the idea of starting
from a blank slate nobody starts from a blank slate not charlie
parker nor homer nor ludwig wittgenstein started from a blank slate
each in his different way going over a considered ground that became a

new ground as they considered it again so thats what these pieces
started as when i talked them reconsiderations of a ground an old
ground the experience of time of repetition of remembering and
forgetting

so much for origins

but the pieces in this book are texts texts starting from two places
transcripts of the tape recordings i always bring a little tape recorder
with me and memories of the talking these are not the same a
tape recording doesnt record everything the audience hears and sees
or fails to hear or see and it records what they dont hear room
noises slips of the tongue or irrelevant hesitations while the raw
transcriptions dont catch meaningful intonation patterns or shifts
in vocal quality so composing the texts involves a restoration from
a memory but its also something more there are occasions when
the allotted time for the talk or the circumstances are too limited for
the material and i feel a loyalty to the material an obligation to take
it further to articulate it more sharply so i do but theres another
loyalty to the audience that made it possible and helped bring it into
being and to the performance situation it was part of

so in composing the texts i work between these two loyalties its
not an issue of polish sometimes the pieces turn out to be very close
to the raw transcripts and sometimes they can be twice as long but
always i hope bearing the marks of their origin in talking and
thinking at a particular time in a particular place and to ensure that
these texts preserve their traces as talk ive tried to distinguish them
from printed prose by dispensing with its nonfunctional markers
regular capitalization most punctuation marks and right and left
justification which i see as merely marking propriety and making a
dubious claim to right thinking and right writing

as for the book its an assembling of pieces that have come together

in my mind as a kind of open work structure i hope to offer as
provisional housing for a number of elusive bright colored
migratory meanings

<div align="right">

david antin
12/1/04

</div>

the

theory

and

practice of

postmodernism a manifesto

about two years ago elly and i decided we needed a new mattress
or maybe elly decided it because i didnt pay much attention to the
problem
 we had an old mattress wed had it for years and the salesman
wed bought it from had assured us it would last us a lifetime and it
was getting older and lumpy or lumpy in some places and hollowed out
in others and i just assumed it was part of a normal process of aging
it was getting older we were getting older and wed get used to it but
eleanor has a bad back and she was getting desperate to get rid of
this mattress that had lived with us for such a long time and so
loyally that i thought i knew all its high points and low points its
eminences and pitfalls and i was sure that at night my body

worked its way carefully around the lumps dodging the precipices
and moving to solider ground whenever it could

but maybe eleanor
sleeps more heavily than i do i have a feeling that i spent much of
my life at night avoiding the pitfalls of this mattress that i was used
to and it was a skill id acquired over the ten or fifteen years of this
mattress' life so i felt there was no reason to get rid of this mattress
that had been promised to us by a salesman who said it would last the
rest of our lives i figured we were going to live long lives i didnt
think we were anywhere close to dying so neither was the mattress
but eleanor kept waking up with backaches

still i figured it was a good mattress and that elly just didnt have
enough skill at avoiding the lumps it never occurred to me that the
mattress was at fault so i didnt do anything and elly didnt do
anything because shes not into consumer products and hates to go
shopping but by the end of a year elly convinced me because she
has a sensitive back and i dont that she had a more accurate
understanding of this business than i did so i said sure eleanor
lets get a new mattress were rebuilding the house as long as
were going to have a new house we may as well have a new mattress
but eleanor said how will i know its a good one i dont want to get
another mattress that gets hollowed and lumpy and gives me backaches
when i wake up how will i know how to get a good one
i said well open the yellow pages and well look up mattresses and
therell be several places that sell them and ill close my eyes and
point a finger at one of these places and it will be a place that has
lots of mattresses where we can make a choice as to what constitutes
a good one by lying on them
now elly really knew that you cant just walk into a place and buy
a mattress she knows this about american consumer goods and

she knows that these places would be equipped with rich delusional
capabilities whatever they might be

we would go to a great warehouse with subdued lighting where
they played somniferous music that encouraged you into restful
comfort while people would be heard talking in hushed voices walking
about examining the mattresses or testing them by gently reclining on
them "oh are you buying that one my aunt sylvie had one just
like it and practically lived on it"

"thats a wonderful mattress my uncle everett suffered for
years from lumbago that never let him sleep he bought that mattress
and slept like a baby ever since" "my aunt agnes had asthma and
she used to wake up every hour gasping for breath since shes been
sleeping on that mattress she sleeps like a log she rises fresh every
morning and plays three sets of tennis every afternoon and shes
seventy-three"

so eleanor said i cant deal with that and i said okay el what are
you going to do she said ill call carol

carol is our expert carol has
been an expert in anything domestic that weve ever done all our lives
because were definitely not carol has been our great expert on
everything gardeners carpenters eleanor calls carol and its hard
sometimes carol may have a new husband and then shes living
somewhere else and youve got to find her shes an expert on
everything but men or shes an expert on men but she changes
them fairly often shes been married five times and each time it
seems fine but then it turns out after a while its not fine or not
fine anymore so she has to change men and probably changes
mattresses with them so she should be an expert on mattresses

but for some reason carol is unavailable shes on a jury or shes
managing someones election campaign or consulting on somebodys

math program shes inaccessible and cant return ellys phone calls

 i said well youre going to have to call somebody how about a
chiropractor youve got two chiropractors they ought to know
whats good for your back

 she said which one should i call? i said call
them both she said which one should i call first? i dont know i
said why dont you call akasha? akasha is a sikh not from india
but from los angeles hes a wonderful chiropractor but hes a los
angeles kid who grew up to be a vegetarian and a los angeles dodger
fan and a sikh he has a pale white bread looking face under his
white turban but he knows all about diet and he can stick you all over
with little pins and he has wonderful hands and when he presses
your back your pains magically go away sooner or later but we
dont go to him for the diet or the exercises he can teach or for classes
in shamanism or even for the little pins but for his wonderful
hands he has more excellences than we can rightly enjoy but we
go to him for his wonderful hands and we have conversations about
the dodgers and the padres while he makes our back pains go away
and eleanor calls him but it turns out that mattresses are not part of
his expertise

 he tells eleanor he knows nothing about what separates a poor
mattress from a good mattress and he suggests we call nikolai he
should know more about mattresses he lives in del mar

 i find this frankly puzzling nikolai is our sloe eyed weight lifter
chiropractor who used to be part of the sixties alternative scene in la
jolla that ran the unicorn a theater that showed only classics and
ran mithras a bookstore that specialized in spiritual healing but
now that the sixties and the seventies were over hes become a
chiropractor to upscale del mar and has to control a taste for rich food
in pricey italian restaurants akasha figured he would know about

mattresses i wasnt sure of the logic but nikolai had played the
weight lifter in eleanors last movie and i figured hed be willing to
share whatever knowledge he had
 but he was attending a conference
on chiropractic somewhere near aspen and elly couldnt reach him
 elly i said if you want a mattress today and you wont come back
into the house without a new mattress were going here and i
point to an ad in the yellow pages that says
 THE MATTRESS WAREHOUSE
 but they have two locations one is in encinitas eight miles to the
north of us and the other is on miramar about five miles to the south
so elly worries should we go to the encinitas store or the one on
miramar id made the mistake of not looking before i showed it to her
 i said we could call them and find out which one has a bigger
stock i dial the number a woman answers and i say i have a
serious question if i was looking for a mattress and i wanted to make
 the most responsible connoisseur choice of the mattress of mattresses
to which of your two stores should i go she said i dont think theres
 any difference i said you mean you dont have a bigger inventory in
one place than the other? she said i dont know i really dont think
so so i said eleanor lets go to miramar its a little closer she said
but what if the encinitas store is better? i said lets go to miramar
 and if you dont like what you see there we can go right to encinitas
 well go to both of them and then you make your decision
 we drive out to the one on miramar and its in one of those
 little malls with a vietnamese restaurant a shoe store and an aerobic
studio for women and theres a big empty looking storefront that says
 THE MATTRESS WAREHOUSE
 its encouraging i say theres a big truck outside filled with
mattresses elly says yes but the place looks as blank as a tire store

it doesnt look very impressive i said well the mattresses are all
lying down on the floor and youre looking in the window

so i get her into the store and we start looking around trying to
figure out where to start and there is a helpful little man an
elderly irishman with freckles and gray hair and very laid back and he
wants to know if he can help us

can you tell me where the better mattresses are asks eleanor

it all depends on what you want my dear

i want something eleanor says thats firm but comfortable

no i said eleanor you want it to be more than firm every
time you talk to me about a mattress you want it to be hard because
youre afraid youll sink into it

the little man smiles if you really want it to be hard you want
one of these he says pointing to a pastel blue mattress right next
to us but if you want it to be luxuriant and hard at the same time
you want one of these and he leads us a little further into the
showroom the mattress hes showing us is a salmon colored one with
some odd looking padding on the top that makes it softer my wife
he says loves this one she wakes up fresh every morning and makes
me breakfast all because of this mattress he runs his hand lovingly
over its padded surface go on he says try them all

now this mattress is only some incredible price like $890 or $750
i dont really remember but it was some outlandish price to somebody
like me who figures you pay around $100 for an okay mattress but
this is a special top of the line mattress i can see that for somebody
with a sensitive back so i say nothing and he tells ell go on try it
try them all you can only tell what you like by trying them so
elly starts trying mattresses

shes lying down on one mattress and then shes popping up and

lying down on another and then shes beckoning to me to lie down
with her to make sure that she really likes it and shes somewhat
liking all of them because theyre all new and better than our old
mattress to start off with but mostly shes not sure and were lying
on them and reclining on them in different positions and im
beginning to get a little embarrassed by all this because other people
are starting to come in and theyre looking at mattresses and
looking at us to see how were lying on our mattresses and there are
certain things you do on mattresses that youre not going to try out in
public either so im not really sure either

meanwhile workmen are bringing in more mattresses and people
are walking around looking and feeling mattresses and looking at us
because were a little less uptight about lying around in public and
im beginning to feel like a specimen in a laboratory or a zoo animal
but elly isnt disturbed about it at all and keeps running around
looking for new mattresses with different kinds of support systems that
our nice little irishman kindly shows us

but the proof is in the pudding
he says in the end its your bed and youve got to lie in it

so elly keeps
on testing and ive bailed out because im not really into this ive been
doing it sort of but i keep thinking that what you do with a
mattress is you learn to live with it you know? somehow you
learn to live with its defects everything made in america is built
with defects right? i figure that defects are the name of the
american consumption game

but eleanor believes in perfection and marcia thats my sister
in law has already told eleanor that if you want a great mattress a
really great mattress you have to get it custom made

7

i said eleanor forget it i wouldnt know what to tell them to custom make would you what do you mean custom made i would have to know what constitutes its greatness do you know what constitutes mattress greatness

she said no so i said forget custom made custom made is for people who are geniuses they know all there is to know about what mattresses should do i dont have any idea what a mattress should do except that its there to be slept on and not get up and bite me i want a mattress that will leave me alone and ill leave it alone but were going through this whole mattress routine and finally eleanor has it narrowed down to two mattresses meanwhile our friendly irishman has told us his life story

he is it turns out the nephew of a famous cinematographer who made a lot of famous bad movies with great cinematography and its through the inheritance from this dignitary that our friend lives in a comfortable house in encinitas where he spends a lot of time when hes not selling mattresses puttering around in his garden or watching public television hes found out that we work in an art department and has some questions he wants to ask us about a program he saw last tuesday about an artist named botticelli what did i think of him

hes pretty good i said yeah there was this one painting it was beautiful you mean the springtime lady i said thats right she was coming out of the water and she had long hair and she was stepping out of a seashell i said very beautiful he said yeah i said very beautiful not anybody could draw like that he said so exact you could tell every line he put down was just where he wanted it to go thats right i said just where he wanted it to go then this other artist who painted a ceiling for the pope that must have been very hard to do lying on his back all the time

very hard indeed i said it took him years to paint it he must

have had a very good mattress to lie on his back that long and get it
 right
 thats the kind of mattress you want he said yeah eleanor wants
a mattress that would last long enough for her to paint the sistine
ceiling fifteen years or more or whatever would be necessary
while the pope kept bugging her i believe this would be the right
mattress for you he said to eleanor whod just returned from an
exploration of the furthest corner of the showroom and he pointed
to a mattress with a particularly elaborate cushioning on top
 eleanor pops onto it lies flat for a moment then pops up again
 i dont think so she says it was not rigorous enough it was
hard enough underneath but it was too soft on top and you could
sink four inches in before you hit rock bottom four inches and my
back goes out at least i think so
 at this point im getting slightly desperate i want to get out of
there eleanor i say if you dont like this one why dont you take the
one next to it it has no padding and its solid rock all the way down
 this is no solution but she finally makes a choice and the
mattress of her choice is as hard as a rock i figure i can sleep on this
fucking rock and our little irishman is writing us up while the other
salesmen are telling us what a great choice we made were out the
door and into the car and eleanor says i think i made a mistake so
we go back into the showroom and eleanor says im really sorry to
trouble you but our friend is not troubled my dear its no trouble
its your choice and we want you to be happy with it
 so eleanor goes back and starts over again but she decides fairly
quickly this time that it was the other one of the two finalists the
pastel blue one with a little padding over the rock shelf am i right
she asks youre right i say and our friend writes it up but this
one is going to be delivered to us in a week and we could have had the

other one the next day so well still have to sleep on our old one that

im used to which is fine with me because im used to it its my old

friend i know its hills and valleys and im happy driving home

 were halfway down miramar road when eleanor says to me david

do you think we made a mistake? i said no i didnt make any

mistake no mistake i said

 but what if its the wrong one she said

well get used to it i said but seriously she said what if its the wrong

one? i said what would be the right one? eleanor forget it it doesnt

matter you know what luther said when he was confronted by the

disciple who wanted to know what to do if he wasnt sure whether or not

he was in a state of grace? he said "sin bravely" i said dammit we

dont know if we got the right mattress we dont know if we got the right

mixmaster we dont know if we got the right anything theres no way

to know let us live cheerfully in our ignorance and we went home

 two weeks later the mattress arrived for fifteen minutes elly

wasnt sure theyd sent us the right mattress because we couldnt

remember the name of the mattress shed chosen but i said im sure

they gave us the right mattress why would they send us another one?

but before we got into that we found the bill and the numbers and

name on the bill appeared to correspond fairly reasonably with the

label on the mattress we think

 so now were sleeping on the great mattress that eleanor selected

so carefully for us and she still has back troubles but theyre not as

bad as the ones she used to have so either this is the best possible

mattress for her and for us or not and this is the situation that i

think best describes our postmodern condition with respect to which

i believe in taking descartes' advice if youre lost in a forest and you

have no idea which way to go go for it straight ahead because

its not likely to be any worse than anything else

the los angeles county museum of art was putting together a huge
california show and paul holdengraeber called to ask if i would kick off
a series of talks on the california experience with my resolutely new
york accent i was a little doubtful and suggested they start with gary
snyder or mike davis or my friend allen sekula

but paul thought gary was too shaggy for sunny southern california
davis was too jeremiahlike and allen a little too grim to start the series
so i figured that california was filled with so many immigrants and id
lived here for over thirty years i could find a way

"what will you talk about" paul asked and i said

california—

the nervous

camel

the reason i was asked to talk here is obviously that im not a
native californian so i must have a clearer view of california coming
from three thousand miles away and theres a certain justice in
supposing this because its very hard for fish to get a clear view of
water while if youre a land dweller and come into the water you
experience it somewhat more sharply than if youd always lived
there

but ive been living here for a long time i came to california

back in 1968 after staying away from california for a long time how
long im not that old but id stayed away from california almost as
if id been resisting it i had traveled around the united states as a kid
a young man id been to the northwest the middle west i knew
some of the south i knew new england but somehow id always
stopped at california and i dont know why though it may have come
from my earliest experiences of california which were of course
representations of california

everybodys heard of california but what
id heard was probably not very much like what everyone else had
heard the first memory i have of california made me a bit nervous
i guess i was about three or four and my next door neighbor was a
little kid who was called gedaliah inside his house and jerry outside
in that part of boro park we lived in two different countries in those days
inside my grandmothers house where i lived then we lived in
eastern europe and my family spoke a variety of eastern european
languages that were all very pleasant to eavesdrop on but outside we
spoke what they used to speak in brooklyn which was the true
american english and so you can tell from my accent that im a truly
native american so if i heard this outside sitting on the stoop i
heard it from jerry but if i heard it inside sitting on the covered porch
i heard it from gedaliah and i think i heard it from gedaliah that he
had a brother an older brother and i wondered where he was
i didnt
wonder all the time you know as a kid youre busy all the time
youre playing marbles youre walking around the corner to watch the
police change shifts at the police station across the street so you could
admire their crisp blue uniforms and bright brass buttons as they
marched out of the station two by two the way you admired the
department of sanitation workers for their fancy gloves so you had

a lot to do but somewhere in the midst of all this i remember asking
gedaliah where was his brother i lived right next door to him in a
nice little house with a covered porch and a glider inside where we
could sit in the evenings eating salmon sandwiches on silvercup bread
and listen to the lone ranger on the radio

but id never seen his brother and i wondered why so i asked
him where is your brother and gedaliah said he was killed by an
airplane on the beach in los angeles

now i was a smart little kid and i knew that los angeles was in
california and the image has never left me this image of a plane
diving on the beach in los angeles as i saw it this tall handsome
athletic looking guy in a bathing suit was standing on the beach
talking with two girls who were admiring how handsome and athletic
he was when at some point he suddenly left them to go rushing
into the water because thats what you do at the santa monica
beach

i didnt know about santa monica then

but i imagined him racing
madly down the beach to dive into the surf and just as he rushed
into the water a plane fell out of the sky and killed him that was
something to bear in mind when i thought about california

and then i had another experience that probably stood in the way
of my coming to california i had a very interesting uncle who i
didnt know too well because lou was a colorful guy who was always
going off somewhere doing interesting things being a ships steward
or a labor organizer that was back in the thirties and he looked
like douglas fairbanks jr a stocky little guy with a dandyish
moustache i remember him mainly from a snapshot that looked like
it was taken in old encinitas

he was standing next to a model A ford with another guy and a

couple of women under the kind of dusty evergreens that lined highway 101 and theyre all standing there in the late afternoon sunlight lined up with their arms around each other smiling into the camera waiting for their photograph to be taken a photograph that in my memory was already brown

and i remember a time when i was a very little kid between three and four and i was sitting on the porch with him when a team of baseball players came trooping across the street they must have been coming back from a game because they were still wearing their uniforms those neat gray uniforms with red socks and i must have been really impressed with them because i turned to lou who was the nearest adult and asked him what team they were and lou looked at them and said "the red sox" and i got hysterical with laughter because they were wearing red socks and we both knew they werent the red sox and i thought this was so funny i never forgot it even after he went away because one day he went off again and we didnt hear from him for a while but then we got a telegram from california saying he fell off a cliff in yosemite

californias had a disastrous effect on people i knew and i was scared to death of it and i didnt know how scared i was of california but i never got here

and at the same time i had another view of california a kind of golden view because when i was a little older and no longer living with my grandmother and my aunts but living with my mother

my mother was a professional widow one of those people who made a profession of having been a widow my father died when i was very young and this was a great misfortune i suppose but i cant decide whether it was a misfortune or not i always thought the

great misfortune was that i wasnt an orphan

but in one of those periods when i was living with my mother in a state of irritated discomfort

my mother had come from a jewish family but she had the character of an irish catholic she was someone who would have loved to crawl on her knees and push a peanut with her nose around the fourteen stations of the cross shed have loved to have been a catholic and many times i said to her why dont you convert so you could do penance you could flagellate yourself you could wear sackcloth and ashes you could do all these great things that catholics are set up for and jews are not you could annoy priests by confessing to imaginary sins but my mother didnt have the courage of her nasty self lacerating convictions and she insisted on being jewish in some vague panreligious way and she liked to read spiritual books that proved that all religions were one religion though she was really probably only a superstitious atheist trying to cover her bets but one of her basic strategies was to deny herself whatever she could identify as pleasure and one result of this strategy was our unfortunate little radio a little yellow bakelite radio that used to sit on the night table

now that i think of it it was kind of pretty a little rounded yellow plastic radio with a tiny speaker but it was dying for all the time that we had it it was dying and i had to sit with my ear to its little three inch speaker to listen to my favorite radio programs in order to hear the jack benny show and it was from the jack benny show that i listened to on our little yellow radio that i got my golden image of california

it was from the jack benny show that i learned about places called azusa and cucamonga and to this day i cant imagine anything as wonderful sounding as azusa and cucamonga i didnt know what they were like but their names rang in my ears beautifully

cucamonga sounded more like an animal than a town or a ranch but whatever it was it sounded great

and of course the jack benny show made southern california seem like a kind of golden rural space small townish and golden and maybe it was in the 1940s

but i know it caused an enormous anxiety in me many years later when i was working as a consultant for this very museum at the time maurice tuchman was putting on his art and technology show and maurice and i had a falling out about the show at one point or another because i was one of the consultants whose consultations were not being paid enough attention to this happens among friends and it was a long time ago but one of the things i was doing for the show in my role as consultant was acting like a kind of preliminary matchmaker sizing up the situation at corporations that thought they wanted to take part in the show by collaborating with one artist or another and this part of my job was to check the fit between the artist and the corporation

so i would go out as a kind of scout to see what the real situation at the corporation would likely be if we sent a particular artist out to work there and i remember one of the artists i was scouting for was ron kitaj who wanted for some reason or other to work with the design group at lockheed and the people at lockheed seemed to be willing to work with him so i had to go out to lockheed to look at the situation and when i learned that the lockheed plant was in burbank in the san fernando valley i was very excited because i knew from the jack benny show that the san fernando was a verdant farming valley and i wondered what a high tech aerospace outfit was doing tucked into the soft green fields i knew so well

that was back around 1968 or 69 and because i was looking forward to this whole adventure i decided to rent a little mustang

you know those tiny fords with crisp lines that looked like sports cars
but werent they had these tiny little engines and had their weight
so badly balanced you had to put sandbags in the trunk to keep them
from slewing around on a turn so here i was in my little mustang
and i was about to drive through up and over one of the canyons
benedict or laurel to see this technological marvel of a building
tucked into the green farming valley

now los angeles was a very
beautiful city and it still is in many parts of it a beautiful city in spite
of everything that human beings have done to it and these canyons
are among its most beautiful parts

so i drove up the canyon to the crest
and looked down and was totally shaken mile after mile of little
pastel colored stucco houses laid out one next to the other like places
on a sunken monopoly board lying atlantislike under a strange grey sea
that i realized had to be smog jack benny had misled me

now i probably never would have come to california except for
my friend allan kaprow paul brach was starting a radical art
department down at the university of california at san diego and
wanted allan as a combination artist and intellectual to come out and
anchor it but paul couldnt persuade allan to come out to california
at this time and allan suggested he hire me i was a poet and critic
an art critic and doing doctoral work in linguistics at the time i
didnt know paul but i knew he was a serious painter but id never
heard of the university of california at san diego as far as i knew san
diego was a marine base but i asked around and found out it also
had scripps institute of oceanography a hot molecular biology
department and some terrific physicists and all these scientists were
standing around with an open checkbook under a palm tree my
friend jackson maclow told me they also had a great experimental

music department and paul was a charming guy and he was able to
sell me on coming out to run their art gallery and teach art

why me i was finishing a doctorate in linguistics im only an
art critic and poet what do you want from me i dont know
anything about teaching art no he said itll be very good people
will come to your classes they wont know what youre talking about
youll be talking about art itll make them feel better because youre
talking about it so its all right that they dont know what youre
talking about

so i said but eventually theyll figure out what im talking about
and then what do they need me for and he said thats when they
graduate i said oh i see

i had never thought about being a teacher
i was studying linguistics because i felt like studying linguistics i
was interested in it and i liked it i wasnt looking for a job im a
determined independent elitist and i dont give a damn about doing
anything except what i feel like doing but what i felt like doing was
thinking about things and talking about them so i figured if they
dont mind my talking ill talk about whatever interests me and theyll
come to class if they feel like it and if they dont theyll go away just
like in a european university but i didnt know if i could do this
because my wife eleanor the artist eleanor antin was busy making
art in new york as i was busy writing criticism in new york but it
turned out fortunately that we were both very bored in new york
in 1968

new york in 1968 i know when you read the art magazines if
you read the art magazines youll think that new york was a
wonderful hotbed of exciting art in 1968 it wasnt but if you read
the art magazines youll believe this at any time in the world because
thats the job of the art magazines to create the illusion that

18

something terrifically interesting is happening all the time and it
isnt its happening very rarely if youre really a veteran of an art
scene you go around desperately looking for something interesting
about one in a thousand shows is worth looking at or maybe its
really one in a hundred

its a sad story but we know this the members of the secret
society that make up the art world know this but the art magazines
have glossy pictures nothing looks better than a glossy picture in
an art magazine and they print these promos everyone is promoted
because thats the job of the art magazines its to make the whole art
world look more exciting thats why they receive their
advertisements from all the galleries and the museums its to make
their whole world look exciting so youre bound to think it was a
terribly interesting time in 1968 in new york city but it was really
kind of boring

at this particular moment the minimal art which had been
brilliant in the early sixties and which i had written about and
admired had gotten tired it was becoming a kind of academy by 1968
it had lost its abrasive edge and needed a rest as we needed a rest

we also needed a rest from new york we were native new
yorkers and we were sick and tired of the city sick and tired of the
intense feelings of the city and one of the things about new york thats
different from southern california is its the kind of urban space where
everybodys very close to everybody else you get the feeling that
everybody is sitting in everybody elses lap you have no room and
you have no privacy you cant afford privacy so everything is built
close if you made loud love in your apartment theyd hear you next
door if you have an art idea and speak about it in a bar itll be
turned into an artwork by somebody next week before youve finished
thinking about it

thats why everybody in new york is very secretive when a new
york artist gets an idea for an artwork he keeps quiet he probably
notarizes the idea because hes afraid someone will steal his great
idea which is probably that he intends to make a sculpture thats
completely horizontal or build it out of pillows or swiss cheese

nobody has ever made a sculpture out of swiss cheese though
henry moore might be assigned primacy in the genre but at the
same time everybodys also talking to everyone else about whats the
right kind of thing to be doing whos doing it whos starting to do it
and whos no longer doing it and because everyone is sitting in
everyone elses lap everyone is looking over everyone elses shoulder
and wondering whether theyre doing the right thing because
everyone is listening to everyone elses conversation and eleanor
was getting very tired of this and thought it might be nice to get away
from it so she said look im busy why dont you go scout it out

so paul brought me out to visit san diego now san diego is the
very bottom of california its almost mexico which is exciting of
course but at that time 1968 the only people who knew that
were living invisibly in this part of california because all the spanish
speaking people lived in places that you didnt immediately get to see
when you were brought in to work for the university

anyway they bring me out here im flying out here and i had
to fly out through los angeles and as the plane is approaching what i
think is los angeles i look down and see something very strange i
see all these blue gumdrops little rounded blue gumdrops and i
have no idea what in the world this is

coming down lower and lower
and seeing them closer i begin to realize theyre swimming pools
with softly rounded edges and curved like little trays and it was
strange enough to see them sitting in this tawny sandstone landscape

curiously planted with the kind of palm trees you expect to see on the coast of algeria

so you dont really believe in them and then just as we land theres a little earthquake a little earthquake can you imagine what a little earthquake is like the trees shake the earth moves gently under you i started to laugh i thought this was ridiculous so i called elly and said youve gotta come ive just been through a little earthquake the palm trees shook cars moved one foot each water spilled over the borders of the swimming pools who knows what could happen here

californias the place to be its either going to lead america over the cliff or its going to lead it back this is the right place to be now how did i know this

i guess i knew it from the look of the buildings the brightness of the architecture and the way people lived in them every building i saw had a skin over it that looked at first like concrete but you can tell its not concrete because they paint it and people dont like to paint concrete because they think its natural like stone but this is a thin skin they call stucco that they spread plasterlike over lath and chicken wire and they paint it pink or blue or green or yellow or even sand color and none of these little buildings ever has a basement theyre jacked up on cinderblocks over shallow crawl spaces for the water pipes the electrical conduits and the gas lines coming from the east i had never seen so many houses without basements or in many cases without underfloorings and when i thought about this i realized i was looking at a bedouin encampment this was a nomadic group and everybody here was ready to go

theyre really ready i said to myself maybe theyve got an idea here theres something about the earth that leaves us as bedouins and maybe its more obvious here

now its true i didnt experience this all at the same time part of
it was when we came in when we moved here my little son was one
year old so he wound up speaking with a california accent which i
dont have

but we were in this little house first thing wed never lived
in a house in new york you dont live in a house you live in
apartments well some people do but in manhattan most people
dont and we were coming here from living in a newly renovated
apartment over a ground floor mafia undertaking parlor which
was nice and peaceful in a lebanese neighborhood that had very
good little restaurants that all had signs in the window in arabic
reminding people that politics and religion were not discussed here
thats how things were kept peaceful in this otherwise rather volatile
neighborhood which was right near atlantic avenue where they
had these wonderful shops like the one run by the sahadi brothers
where i used to go to practice arabic

it was a wonderful place but when we were moving to
california we knew that we were going to be confronted with having a
house where would we have it?

paul said ill get you a place in la jolla and i said not on your
life

i had seen la jolla when i first visited and la jolla is very pretty

it was 1968 when i first visited and i was sure that i had been
returned to 1952 all the women wore white gloves i hadnt seen
anything like this since the fifties and even then living in new
york i hadnt seen very much of it and here there were the people
who lived in la jolla in rancho santa fe and on point loma theyre
pleasant people awfully pleasant as pleasant as wonder bread the
men wore dark blue blazers with brass buttons and cream colored
pants with checked shirts and they all watched the stock market and

played golf and tennis paul i said find us some funky place in the
north county and paul was wonderful he came up with a little
house in a town called solana beach solana beach was one of those
little towns that stretched along old highway 101 and the house he
found us was a little white house surrounded by enormously high
oleander hedges in a way this gave us a kind of european garden
walled around by ten foot high oleander bushes in all their poisonous
beauty and within the garden was a giant pepper tree and orange
trees tangerine trees a peach tree for us it was incredibly beautiful
but we didnt know anything about house living

one day im walking out of the house and a neighbor says to me
its disgraceful and i said whats disgraceful and he said your tree
is hanging over my driveway and i said its not my tree and he
said what do you mean its not your tree and i said i rent it from
the person who owns it and this tree has been here for years its
been minding its own business for years and he said well it interferes
with my camper every time i pull into the driveway and i said we
could call the owner and see if hed like to have the offending bough
cut off

but this was all kind of new to me people living next to you
complaining about a tree i could imagine complaining about parties
running late into the night because they mightve heard a party late at
night though you couldve had an orgy in the garden and nobody
wouldve known as long as you kept quiet because we were sealed off
by the tall oleander but living here among the houses of this small
town solana beach the towns of this part of southern california line
the highway

not the new highway thats not so new anymore I-5 but the old
coast road all the commercial buildings are lined up along the coast
road with the houses beginning a block back on either side the older

part of town is the west side where the houses get bigger and more
expensive as they move further west with the prime real estate
overlooking the ocean even though some of the houses are kind of
shambly on the bluffs over the water and we had lucked out and we
had this beautiful little place in the old part of town even though
we didnt know whether we were going to stay

but we began to understand the nomadic nature of the
environment soon after we got there because a couple with a camper
moved into the house right across the street just a few weeks after we
moved in they were a handy couple and they started fixing up
things as soon as they moved in they put up a new fence they
painted the house they trimmed the trees they changed the entrance
they were always tearing something down putting something up
they worked like hell and we thought they were really building their
lives after a little while theyd be able to sit back and enjoy the
results of their effort but six months later they sell the house to a
retired couple and theyre gone it seems they made a business of
buying houses fixing them up and selling them to some sucker for
more money or maybe theyre not suckers either because they can
live in that house for five years and sell it to somebody else for even
more money

which is the way that a lot of people acquired capital in southern
california this is the southern california style you buy a house
live in it a little while and then sell it and you can count on the
continuous inflation for your profit eventually you buy houses you
dont even live in and sell them for more money and finally you
become very rich and move to la jolla or rancho santa fe where you
have a golf course at your back and you buy a blue blazer and you give
up your little camper for a mercedes or a bmw and you turn off the
country music because youre not a redneck anymore so you tune

into the top forty or easy listening stations and you send your children
to private schools where they learn to be as bland as you

we saw this happening again and again and we thought there
must be a message here but we werent prepared to enter this game
of musical houses first because we didnt know if we wanted to stay
in california and second because we didnt really understand it so
when the owner of the little house with the giant oleanders offered to
sell it to us for about $16,000 because he liked us and because we took
such good care of the beautiful garden he had planted and because he
had no need of it we said we dont really know and a woman from
fallbrook bought it she moved in chopped down the oleander so
you could see she wasnt having any orgies cut down the pepper tree
severely cut the fruit trees and hung plastic plants on the porch to
prove she was a decent citizen so this was a california life we didnt
understand

but we lucked out we had a colleague a writer named reinhardt
lettau who was a professor in the literature department of the
university a disciple of herbert marcuse who was a professor in the
philosophy department back then and reinhardt like many of us
was against the vietnam war that was raging back then but
reinhardt who was a bit of a hysteric was against the war in a
way that made a lot of noise and in the course of things a marine
recruiting officer came to the campus and when he was preparing to
make his pitch reinhardt was outraged and went up and slapped him
on the head with a rolled up newspaper naturally the television
crews were there with their cameras and reinhardt was featured on
the evening news

now reinhardt lived in a shambly old green stucco house with a
tile roof on the bluffs over the water with a grand terrace from which
you could track the whales or look seagulls in the eye he lived there

with monique a strict maoist whose dark hair was severely cut
straight across her forehead among posters of lenin and mao and
the uprising in paris of the year before and this house was owned
by an elderly lady who lived in la jolla and rented the house to
reinhardt for about $160 a month and when she turned on channel
10 at five oclock that evening the local news was playing the reinhardt
story and she had her agent tell him he had to get out not
because of slapping the marine officer with his rolled up newspaper
but because he was sleeping with monica to whom according to
channel 10 he wasnt married

"david" reinhardt said when he heard we had to move out of our
little house with the wonderful garden "this is the right kind of
house for someone like you we have to get out but i wouldnt want
it to go to just anybody" and he sent us to talk to wes maurer the
sweet old drunk who ran the philip marlowe real estate agency and
handled the house for the la jolla lady the deal was clinched when
he learned i was a professor at ucsd and married to elly the owner
likes to rent to uc professors he said especially married ones

so we rented the place for $180 a month and we stayed in it a long
time even as it was falling apart because we loved it though we
were eventually paying $200 a month for it and they offered to sell
it to us for $40,000 though they were willing to take a thousand off
the price because they thought we would have to tear down the house

but we still didnt get it we still didnt understand this buying
and selling or owning of things in this way and we thought it was
bizarre a few years later somebody did buy it and they tore down
the house and replaced it with a monstrous white thing that swallowed
the beautiful terrace creating something that we would never want to
look at again

but for all of the eight years that we lived there we saw this kind

of movement of people and things and the feeling i had was again
 that feeling when i saw my first earthquake and wed had a second
little earthquake when we moved into our first house in solana beach
 we had been in solana beach only a month and there was another little
earthquake our bed skated gently across the room and our little one
year old climbed out of his crib and crawled into bed with us and we
knew again the twitch of the skin of this tawny animal california and
 began to think about this
 how california was really like some kind of animal that is very
 amiable patient and long suffering but sometimes it gets nervous
sometimes the tawny skin twitches and the buildings mounted on its
 back move and this happens often enough that whole lives are lived
in relation to this or seem to be and my sense of this was something
 i came to realize gradually after living here for many years
 because we got here before all these great subdivisions had come
in and before all of the great highway that connected all these little
towns I-5 had been completed we lived in the house on the bluff
 over the water for many years and from where we lived you could
see the highway intermittently at night or catch glimpses of it from
 the lights of cars that occasionally passed because the old town
center that was strung out along the old coast road 101 was in a sort
of valley between the bluffs on the west and the hills to the east
 through which the new highway ran
 now I-5 wasnt even completed at the time we moved into solana
beach and south of oceanside it was still a little two lane road then
 but eventually a few years after we came they completed it still
there were relatively few cars running on it especially at night at
 night it was like watching a kind of eccentrically programmed light
sculpture after ten pm car lights would show up once every five
 minutes or so and if you went to your front window or stood

on the sloping lawn outside it that we allowed to become a field of
 weeds if you stood on this sloping lawn and looked toward the
highway after ten oclock you could stand there for five or six minutes
before you saw two or three cars go by after twelve you could stand
there for fifteen minutes without seeing a car go by that was when
 we first moved in but after a while you would see them every two
or three minutes and by now theres no time of the night even at
 two or three or four in the morning its a continuous light show and
things like this have been happening all over southern california

 once there was a little mayfair market at the foot of the hill
leading down from the bluff into town and you could walk to the
market from where you lived this was a little beach town and you
 could walk to the market though some people might drive because
of the hill or because of the groceries they had to carry still we used
 to walk to the market and back and it was no problem but then they
built a mall a shopping center in the hills near I-5 and then
 everyone had to drive to the market even if they lived in the hills
 because there were no streets in the eastern part of the town

 all the time that we lived there things kept changing like this
and i began to have an image of what this was like and i was beginning
 to get an image of what the future would be like the future of
malls someday someone is going to be an archeologist of ruined malls
 because what are they going to do with old malls supermarkets that
no one goes to vacated target stores abandoned for hotter locations
once a target store goes away what are they going to do with the
building make an airplane hangar out of it? you know these vast
 horizontal buildings that house all the goods that anybody could want
on the face of the earth in their reduced forms
 whatever would happen to these weird buildings

well i found out the other day i happened to drive by one of
these new malls they built alongside the highway in solana beach
 that was an old mall now and not too successful they just wiped it
out they bulldozed it out all the buildings that used to sell groceries
and stereos and copiers and bicycles and running shoes and toothpaste
gone and theyre going to replace it with another collection of
 businesses that i guess will be pretty much like the ones they just
bulldozed but newer and the new developer will have to sell the deal
 to some new group of hopeful people who think they can make a go of
it where the old group couldnt and what will they put there? a
bowling alley a frozen yogurt shop a chic boutique a bath center a
massive health food store? i dont know but its all changing
 everythings moving
 in this way california becomes a paradigmatic part of america
 americas nomadic moment thats the sense of where the earth
stands in relation to you it knows youre irrelevant as if you were a
 tourist here everybodys a tourist the indians here knew it well
they lived very lightly and they moved from one place to another from
the seashore to the mountains following their food sources as the
seasons changed gathering shellfish by the ocean and acorns in the
 mountains and they didnt build very deeply today californians
have a somewhat similar feeling about the land theyre not very
 deeply rooted and they build almost as lightly as the california
indians but feeling something is not knowing it knowing requires
something more and my friend richard had this feeling without
 knowing it too well
 we met richard not long after we moved here richard was one
of the most popular gynecologists in the area he was a tall handsome
man and charming and he had a lovely wife alexandra they lived in

rancho santa fe which was the very tailored and wealthy part of
 northern san diego county because he had a very successful practice
he and his friend jack they were an interesting pair these two
handsome young doctors both a kind of study in contrasts richard
was dark with curly hair he could have been an actor a movie star
if he didnt have to act

and alexandra was an elegant blond and blue eyed beauty while
jack was blond blue eyed and boyish and had a tall and leggy dark
haired wife named melissa and richard drove a bronze mercedes
while jack drove a red corvette but they shared this very successful
practice and they were both as generous as they were successful once
a week they each drove down to work at a free clinic in mexico they
took a lot of charity patients in san diego and no artist or artists wife
ever had to pay for treatment so their offices and homes were filled
with the paintings and drawings photographs and sculptures of san
diegos artists

it was through his interest in art that we first got to meet richard
i was director of the university gallery back then and id used my
new york and los angeles connections to put together a show of post-
pop painting that was back in 1969 and it was a more or less
timely show dealing with the reappearance of representation so it
included a wide range of artists of different kinds ranging from
straight pop artists like warhol and lichtenstein and wesselman to the
more painterly styles of alex katz and sylvia sleigh and aside from
the fact that it was a little early to dwell on representation for an art
world hooked on the prime importance of abstraction it was a
reasonably conventional show

but this was san diego in 1969 and the wesselman in the show
was one of his "great american nudes" it was a kind of collage work
with the nearly cartoonlike female figure lying spread legged on a

piece of fake leopard skin fur a completely sexist beaver view nude
and somehow even before the show had opened word got out about
the wesselman

there were already complaints not from outraged feminists
feminism hadnt been born in san diego in 1969 it was still
basically a navy town and the city was living in 1959 or more likely
1951 so the complaints were from puritans or if not puritans
from people with a strong sense of public propriety whatever they
did in their bedrooms or other peoples bedrooms living rooms or
jacuzzis and the complaints were all being fielded by the chancellors
office before being shunted over to the art department where i could
handle them so paul as the department chairman was a little worried
about the opening with the chancellor coming and all the other uc
and la jolla dignitaries

now our gallery back then was one of the strangest art galleries id
ever seen it was the only gallery id ever seen with a black ceiling
it was a long windowless stucco shed that had served as the officers
bowling alley of camp matthews the marine base our campus housed
before the regents of uc acquired it in a land swap with the military
but the school did an architectural remake and spruced up the outside
with a lot of redwood around the entrance and redwood stripping
inside in fact they got so carried away with the redwood stripping
that they hung some from the ceiling making the low ceiling lower
and recessing the lighting fixtures up behind it where they
disappeared into the black ceiling making this the darkest art gallery i
had ever seen they completed the remake by covering the concrete
floor wall to wall with mauve carpeting that gave the place the
appearance of a discreet gentlemans club or a high class funeral parlor

this was the first big show of the season and while i was hanging
the show paul kept popping in and out between classes to see how

things were going because he was a nervous guy and as a painter he
had lots of opinions about hanging paintings but things were going
pretty smoothly id brought in extra lights and managed to get a lot
more on the paintings so you could really see them though i had
the feeling every time paul looked at the wesselman he would have
liked to see it a lot darker

the evening of the opening he got there early while my assistants
were taking care of the last details spraying windex on the few works
with glass over them laying out wine glasses and he hung out with
us till the doors opened and the first few people drifted in but
nothing remarkable was really happening the wesselman was at the
far end of the wall away from the entrance door and like most
opening crowds the first few visitors mainly faculty clustered around
the wine table generally scanning the room pleased to see and be
seen by each other and fortifying themselves with a drink before
plunging into serious picture looking then mcgill arrived

the chancellor was a husky middle aged guy with brush cut grey
hair who could have passed for a brit general if he had a sandhurst
accent as it was he looked like a c.e.o. for g.m. or at&t although hed
been the head of a science heavy psychology department before taking
over as chancellor at ucsd which really is a large corporation and
later he got to be famous for being president of columbia university
another large corporation so i guess he really was a c.e.o.

he came in with a whole group of people among them richard
and alexandra and jack and melissa but unlike the earlier visitors he
untangled himself from the wine table after a few words and a couple
of handshakes to follow richard and alexandra down the line of
paintings with paul inconspicuously bringing up the rear and i
admit i was pretty curious so i drifted over too

they passed the bechtle and the alex katz and came to a dead stop

right in front of the wesselman richard leaned over and peered
directly between the spread legs of the great american nude "left
median lateral episiotomy" he said in a stage whisper everybody
broke up laughing and that was the end of it

now richard was an interesting man they were an interesting
couple he and alexandra richards practice was very successful and
even with his charity work he was living the affluent life of all good
doctors in southern california in those days of tax shelters and
complicated investments before hmos and he and alexandra lived in
a spacious spanish style villa on several tailored acres of san diegos
choice north county real estate with a swimming pool and a tennis
court and servant quarters they belonged to the country club and
played golf and tennis and though they had no children they
seemed to be leading a typical affluent southern california life

in spite of all that they seemed displaced and a little remote
maybe it was alexandras cool east coast style or the occasional
faraway look in richards eye they had lots of acquaintances and
people they socialized with out of habit or convention but their only
real friends were jack and melissa who also had no children the
two couples were inseparable they played tennis and golf together
swam together went to the theater or concerts together and to art
openings and while they saw lots of other people there was a kind
of bond between them that couldnt be explained by the simple fact
that richard and jack shared a practice or that melissa and alexandra
had gone to the same east coast college the only thing they didnt do
together was travel together and they had this passion for travel to
picturesque places but they would travel separately

so if jack and melissa went off to japan or if richard and
alexandra went off to africa theyd arrange to have dinner together at
the home of the returning couple usually alone but not always

and after dinner and brandy the guy would bring out the slide
projector and show the pictures while his wife gave a running account
 of the trip
 i was never at any of these slide shows but i heard that the
 pictures were mostly pretty ordinary if a little eccentric because they
 tended to show the usual things a gondolier on the grand canal or a
 street vendor in the piazza di san marco punctuated oddly by
 unexplained casual images of people sitting in a hotel lobby or a man
 walking into an elevator and while the account that accompanied
 the slide shows was casual and anecdotal there was something
 ritualistic and deeply serious about them as if through this procession
 of ordinary little stories one couple was revealing something secret
 and deep about themselves to the other something no outsider
 could understand
 richard and alexandra had been to egypt
 now i dont know
 anything about egypt when i think of egypt i think of ruth st denis
 looking at a cigarette ad and inventing egyptian dance she didnt
 really invent egyptian dance she looked at that cigarette ad and seeing
 an image of egypt she figured shed discovered the east this was the
 perfect los angeles story it was 1915 and she knew from all the yogis
 running around los angeles that the east was the site of antimaterialistic
 spirituality so she simply decided to push further east because she
 thought india was more spiritual than egypt egypt was just a bunch
 of pharaohs while india was filled with naked yogis or bodhisattvas in
 saffron robes and before you know it she was starting her los angeles
 art institute in 1915 inventing modern dance mostly by placing
 attractive nearly naked people in picturesque poses that she assumed
 were spiritual and erotic because she'd seen them in photos of ancient
wall reliefs or in magazine articles on kootch dancers in bangalore

and in spite of the absurdity or because of it ruth st denis in true california fashion became a teacher of martha graham and one of the great inventors of modern dance

i never saw ruth st denis' 1915 cigarette ad and what do i know about egypt that i didnt get from a pack of camels so thats what i supposed ruth saw a camel standing in front of a pyramid and maybe a picture of the sphinx this is the complete tourist picture and if you go to egypt thats what youre going to see you may tour the old part of cairo you may go look at the suez canal a buried temple or two and youll certainly look at the sphinx but you know that even before you see the pyramids youre going to take a camel ride someone is going to show you how to ride a camel and someone watching will always take your picture and i take it that all these images were in alexandras slide show of their egyptian trip during which richard was completely silent till alex got to the image of the camel ride the picture was not of either richard or alexandra the picture was of a pleasant looking middle aged lady falling off a camel that was neither standing nor sitting but halfway up and halfway down

as alexandra explained the camel driver told the camel to get down and the camel got down the woman climbed on and the camel got up and it went well so the driver let the camel walk a little bit she took two steps and abruptly sat down this took the woman by surprise and threw her off balance so she tried to get off it also took the driver by surprise and he ordered the camel back up but the woman was still half off the camel so when he told the camel to get back up the woman started falling further and he ordered the camel back down the camel dropped down and the woman tumbled completely off in the picture the woman is toppling off the camel on the way to the second sitdown

all through alexandras account of this bizarre incident richard

had remained silent staring intently at the slide and he remained
unusually silent for the rest of the show when asked why he said
the picture reminded him of something he couldnt quite figure out
but by the end he remembered it was the camel after the picture
was taken and the woman had fallen off it was the camel kneeling
there its face he said

it reminded him of the sphinx

now this was just the kind of image that flares up in someones
mind for a moment and is almost as quickly forgotten and richard
never mentioned it again he probably never thought about it again
because though he was an intelligent man he was not an intellectual
he was a doctor and doctors are more like artists and most of their
intelligence is expended in their work so richards life went on as
usual caring for patients in san diego or mexico playing tennis or
golf going to concerts and the theater and to art openings and little
parties but one day jack took his corvette and was speeding down to
the clinic in mexico when a truck carrying tiles from tecate to san diego
pulled out to pass a slower truck and it carried its tiles no further

the bright red corvette was totaled and boyish blond haired
laughing jack was dead

richard never seemed to recover from jacks untimely accident
his life changed completely after that he moved out of his house
and into the servants quarters behind it he stopped going to concerts
and openings where alexandra appeared alone he started spending
more time at the clinic in mexico and even that wasnt enough for
a while he literally disappeared they say he was in an ashram in
india though im not sure thats true but when he came back to
san diego he gave up his practice left the house to alexandra and
took up an entirely new career curiously related to his old one once
he had helped bring people into the world now he was helping them

out of it working with mortally ill people and helping them find a
humanly meaningful dying

 and hed been doing this for some time before we heard of it and
when we did wed been through the dying of a number of friends

 weve
been through the deaths of a number of friends recently elly and i
 we were sitting by watching kathy acker die she was a dear friend
of ours and an ex-student someone we really loved and we watched
her die young and terribly of cancer and what do you do in those
circumstances sitting there you do the best you can but what was
 his expertise what did richard do to make the dying more bearable
more human and we heard this story

 he drove with his cancer patient out into the mojave where they
built a little fire and wrapped themselves up in blankets and camped
out for the night they lay on the ground and spent hours singing
wordless songs then they put out the fire and just looked up at the
stars in the cold night sky and lying there richard began to speak
almost to himself in a voice hardly above a whisper about how far
away these stars must be and how long it takes their light that
travels a hundred and eighty-six thousand miles a second and millions
and millions of years to come down to the earth where it looks so
bright to us while so many of them must be already dead and may have
been dead for millions of years but their light is still with us and
could stay with us for many more thousands of years
 we have to think about our lives that way
 the odd thing was that this cancer patient got a remission of his
cancer and had this story to tell meanwhile i dont know where
richards gone but he seems to have disappeared from california
leaving us to deal with its sphinxlike character and its camels shrug

this was my last stop on a talking tour through three eastern
european capitals whose names all curiously began with the letter "b"
bratislava budapest and bucharest id taken a train from bratislava to
budapest but decided to fly to bucharest in spite of misgivings about
romanian air it turned out that the airline was run by lufthansa the
plane was a sparklingly new fokker and the service was excellent
except they flew us to bucharest by way of warsaw which is like
traveling from san diego to san francisco by way of denver so i
arrived at otopenia airport more than two hours late the airport was a
far cry from the sinister green military hangar we came out into the
last time i was in bucharest where you had to pass through a narrow
cagelike corridor between grim looking guys in camouflage outfits
holding kalashnikovs now you came off the plane into a bright new
modernist building with an information officer talking cheerfully on a
cell phone but it was 8:20 pm and no magda i waited half an hour
then tried the information desk the guy at the desk called for a page
it came over loud and clear no sign of magda i changed some
money and waited a while longer after an hour and a half i persuaded
the guy at the desk to call magda for me from his own cell phone and
got her answering machine i thought about getting a cab to a hotel
but waited another hour when a slight looking kid with glasses
showed up carrying a sign saying he was looking for antonje zalisca and
chris keulemans from amsterdam i figured he must be from café
europa he spoke no english french or german but he knew magda
and said she was at META the name didnt mean anything to me then
but i figured he was supposed to pick me up too chris and nino got in
by 11:30 and we all crowded into his tiny car and drove like hell over
the twenty kilometers to bucharest raced across trolley tracks around
potholes and over badly cobbled streets into a ghostly warehouse
district seemingly populated only by packs of hungry dogs we turned
an implausible corner into luigi gavarni street and came to a stop before

the gated entrance and walled courtyard of a gleaming white modernist
building this was META

we climbed two flights of marble stairs of this darkened art gallery
up to an elegant residence space turned right into a kitchen where
magda mileta and krzysztof were seated around a table with a bottle of
wine peter walked in about a half hour later and we wound up
spending the rest of the night talking about sarajevo eastern europe and
the bizarre american presidential election this was just the beginning
of three days and three nights of intense discussion that made up this
years café europa which was a floating literary café invented by
krzysztof czyzewski a visionary polish theater artist who was
traveling the old soviet empire trying to retrieve ceremonies rituals and
performances suppressed by stalinism the idea of the café was to
bring together writers and artists of all kinds from eastern and central
europe to reflect on their cultural and esthetic situation it met every
year in a different european city this years meeting organized by
the romanian poet and art historian magda carneci included the
regulars krzysztof and magda mileta prodanovic an avant garde
yugoslavian artist and art critic nino zalisca a wildly comic bosnian
novelist and filmmaker along with a few westerners chris keulemans
a sharp cultural critic from amsterdam peter jukes a young british
playwright and two american writers christopher merrill and me

this years meeting was scheduled to run from november 23 to 26
and was bracketed by the bizarre american presidential election which
was still unresolved and the imminently forthcoming romanian
presidential election in which a dangerous and incompetent
neofascist clown named tudor was threatening to defeat the merely
incompetent and possibly corrupt iliescu so this years conference was
appropriately called "the flavor of postmodernism" after three days
of intense public discussion with a fair sampling of romanian artists
and writers and critics and three late nights of even more intense
rambling discussion among ourselves we were supposed to give a final
reading in the conference hall of bucharests museum of romanian
literature a dark wood paneled room whose walls featured photos and

letters from the career of a leftist francophile writer from the early part
of the twentieth century who wrote pretty novels about people from
the levant and got into trouble with his parisian friends for a
disappointed book about the soviet union in the 1930s our readings
were preceded and followed by short performances by a classical
guitarist the readings were poorly attended maybe because
something else important was happening in bucharest or because they
were mostly in english so we were reading for a handful of people
but mainly for ourselves and maybe the guitarist i was the last
reader and of course i wasnt reading i was talking

café europa

that little tune you played at the beginning the little dance it
seemed as if id heard it before a little french dance played on a solo
guitar pretty much the way you played it it haunted me throughout
the readings it reminded me of something something i couldnt
quite remember and now i remember it its the same tune that
haunted a movie i saw many years ago a beautiful french movie
that was made after the war the second world war

but we used to
call it the war because we grew up in it and it seemed to have always
been going on and would never end and we the kids growing up
then we all expected to be in it my cousins were in it one of
them an engineer at the battle of the remagen bridge the other one
a bomber pilot over north africa and italy i think he bombed the
ploesti oil fields that are not so far from here and we all expected
to be in it when our turn came my next door neighbor a
beautiful russian pianist enlisted in the marines and wound up in

the invasion of okinawa somehow he survived it and sent me back a
japanese rifle with a bayonet a beautiful brown piece of wood and
 dark polished steel looking like a farm implement so i was used to
 the idea of the war the way we all were then but when i saw the
 movie it was later the war was over and things seemed different
 then

 but in the movie there was the war again and there were people
 on the road trying to get out of paris the germans were coming
 and the road was choked with cars and motorcycles bicycles and
 handcarts and horse carts people on foot with suitcases and sacks
 people carrying or leading animals and there were these beautiful
 people because this was a film a handsome couple the woman was
 blond and lovely and the man was handsome and intellectual
 looking and they were in a car with a little girl holding a little dog
 and the little girl was also blond and beautiful because this was a
 film and in a film things always happen to beautiful people the
 crowd was trying to get over a bridge and their movement was choked
 by the traffic and as i remember the car stalled on the bridge the
 beautiful couple with the serious and handsome husband was trying
 to start the car whose carburetor was probably flooded just as the
 german planes appeared in the sky the stukas with the menacing
 inflected wings and the beautiful couple took their little girl holding
 her dog and abandoned the car and tried to run for shelter at the side
 of the bridge but the lovely blond woman tripped and fell and hurt
 her leg and the husband kept trying to help her up while the
 stukas made their first strafing pass and you could see the bullets
 advancing over the bridge advancing with little puffs of dust toward
 the place where the husband was trying to help his wife get up but
 she was unable to get up and she was sheltering the little girl who was
 still clutching the dog in her arms

and somehow the bullets spared them and the stukas started
away but then the planes turned for a second pass and the wife still
couldnt move and the bullets progressed down the bridge and the
blond actress and her handsome husband were beautifully dead and
the little girl was left there crying by the roadside clutching her little
dog that was also dead as the stukas flew away

now somehow the little girl got picked up by peasants and thats
when the music started because this was a movie and that was the
little guitar tune you played at the beginning of the readings and it
haunted the rest of the film which concentrates on the two children
the little girl who was about four and the little son of the peasant
family who might have been eight or nine and theres something
childish about the courtly simplicity of the music that went with
the film which is a kind of love story about two children in a
cemetery because the only way they can get the little dead dog away
from the little girl is to provide it with a ceremonial burial which the
little boy does but this wasnt good enough for the little girl who
was probably jewish and had never seen a catholic funeral and now
gets to see one for the first time and shes impressed by the whole
ceremony that culminates with the solemn placement of a cross over
the grave as a sign of peace so she wants to put a cross over the little
dogs grave as a sign of peace which is something the little boy isnt
sure is right for a dog but reluctantly does for the little girl and this
pleases her so much she wants to bury more dead things and give
them peace so to please the little girl the boy has to resort to killing
more and more little animals so that she can place a cross over them
and bring them peace and all the while the music keeps playing the
little court dance we heard at the beginning of the readings

but now the war was over my cousins were back from italy and
germany and the pianist was back from japan my japanese rifle

disappeared i think my mother threw the bayonet away and we
were at peace in america the kind of peace you get on a long skiing
trip when youre surrounded by mountains and snow mutes all the
sounds of the outside world which seems very far away

and i remember a skiing trip to mammoth high in the sierras
on the border between california and nevada and we were there
with my son and my wife and our friends and it was a clear sunny
day with fresh snow that had been falling the whole night before so
we were skiing on powder and i remember stopping on a crest to look
down at the nevada side of the mountain and there wasnt a single
cloud in the sky it was such a great skiing day and so sunny as i was
coming back from the ski slope carrying my jacket on my arm and
still wearing my ski boots that i paid little attention to a dark puddle
of water i was stepping into that turned out to be black ice on which
i slipped and fell breaking my arm and bringing my skiing on this trip
to an end but not wanting to disturb everyone elses skiing i wound
up for the rest of the trip back in our rented condo watching on
television the overthrow of the ceaucescu government here in
romania and this was surely a good thing and encouraging for
romania and i watched it with sympathetic interest but there was
one scene that was so strange i can hardly believe i really saw it on
television the execution of ceaucescu

now i know he was a personal horror and his government a
disaster but there was something strange and foreboding in the image
of the hooded prisoner handled like a puppet the impersonal
executioners and the body that came to lie there inert in this blank
walled space that reminded me of a scene from the life of my wifes
stepfather also out of central europe

peter was a young hungarian poet and painter at least at the
beginning he was a young hungarian poet and that was back around

43

the time of the first world war because he was born in the 1890s and
discovered as a young writer of great promise by the editor of ady's
famous magazine *nyugat* when he was barely eighteen he was a poet
in love with language the hungarian language which he knew and
loved as his own and with french a language he barely knew
 i know because at the least provocation or with no provocation at
all he would recite to me poems in hungarian like ady's *ver es aranj* or
his own poems and he had committed to memory a handful of
poems of verlaine and rimbaud and the whole first page of flauberts
marvelous novella *un coeur simple* which he would recite to me
in a painstaking careful french
 but history wasnt kind to him after the fall of the károlyi
government and the rise and fall of bela kuns even shorter lived
government horthys fascists suppressed most intellectual activity
 nyugat closed down and many intellectuals got rounded up and
thrown in jail and some were tortured and killed and peter was one
of those thrown into prison he got rounded up with a number of
others suspected of left wing sympathies and hauled off to the central
police station where he spent a sleepless night in a bare cell listening
to the moans of another prisoner being tortured in a neighboring cell
while he waited for his turn to come till the early morning when he
got dragged out of his cell manacled and left to stand there in the docks
next to his tortured fellow prisoner waiting for someone to assign
them to their fate
 it was a long wait and his haggard companion could barely stand
and swayed back and forth in a shocked daze and peter expected at
any moment someone to come in with orders to shoot them both
but suddenly there was a sound of laughing voices and a young dandy
in an officers uniform with a beautiful woman in an evening dress on
his arm burst into the room theyd obviously been partying and were

a little drunk the officer pointed to the tortured man and said
something peter couldnt make out and the woman went up close to
 the dazed man screamed "communist pig" and spat into his face
 the officer laughed and the glamorous couple swept out of the room as
suddenly as they came in while peter watched the saliva roll slowly down
the prisoners cheek which he made no effort to wipe but then
another officer came into the police station an aristocratic ex-
classmate of peters who simply pointed to peter and told the police
 official in charge "you cant hold him hes a poet hes not
dangerous to anyone"

 so peter escaped prison and slipped down the danube to vienna
 where he starved for a while and from there to paris where he met
a pretty french girl for whom he recited *"il pleure dans mon coeur
comme il pleut dans la ville"* and she told him his pronunciation was
extraordinaire

 so that was one of the things i was thinking about when i first
visited romania back in 1992 not long after the fall of ceaucescu and
of course i didnt know what to expect except that i had some images
of early twentieth century bucharest as a kind of east european paris
where nearly everyone spoke french so i wasnt prepared for the
billboard images of michael jackson as a byzantine icon or the ten
foot high marlboro man who probably died of throat cancer still
pushing here in eastern europe where nobodys a cowboy and nearly
everybody smokes the cigarettes that surely killed him back in the
united states or the coffee shops selling nescafé instant coffee as a
delicacy or the number of street vendors trading currency and hawking
everything and anything from condoms to audio cassettes while
american movies filled the theaters and king michael was campaigning
for a return of the monarchy as iliescus government was auctioning off
television and radio licenses to unidentified corporate interests in the

interest of privatization and as testimony to the freedom of the
market

but the conference i attended here was wonderful and i listened
to round after round of lectures and discussion by art critics and
scholars from hungary and bulgaria and romania in french and
english and what i could make out of the romanian filled with
intellectual excitement with anger and distaste for the stalinist past
and great hopes for a new and open future and we got shuttled
around the city of bucharest to see the megalomaniac "peoples palace"
ceaucescu had constructed for himself and the streets of fashionable
international boutiques that were selling french german and italian
luxury items at prices i didnt imagine anyone in romania could afford
then we went out into the countryside to see the weird buildings
ceaucescu had constructed for the people hed forced out of their
traditional homes into modernist potemkin villages hollow concrete
blocks in which people huddled against a winter without plumbing or
electricity as a sign of romanias modernity and of course we got
shown around the ruins of count dracus castle by a caretaker who was
hoping to immigrate to cleveland where he had relatives that were
doing pretty well

so i remembered with some anxiety the tv images from my
interrupted skiing trip the blank prison cell the hooded prisoner
and the faceless executioners but then we were offered something
very special the curator of the big bucharest museum a husky
whimsical guy in motorcycle boots who looked more like a paratrooper
or a beat poet than a curator had organized an exhibition expressly for
us the conferees at the national academy of sciences and we
trooped into the museum where he had arranged all the paintings of
ceaucescu and his wife that had been offered to the museum over all

the years of their reign and there they stood dozens of paintings of

president and madame ceaucescu side by side and arm in arm and
always holding a lily in paintings of every style from nineteenth
century realism through a kind of monet-like impressionism a
 seurat or pissarro pointillism and even van gogh like expressionism
this was surprising but what really made the exhibition were the
sculptures because our curator friend had put on display in the same
hall on a slightly elevated but very large platform all the sculptures of
president and madame ceaucescu and there were dozens of these too
in the same pose and he had lined them up left to right in size places
 the way we used to line up in elementary schoolyards waiting to enter
our classrooms

and though this was a special exhibition and no one else was
allowed to see it looking at all these ceaucescus side by side and arm
 in arm and always holding the iconic lily in statues running in size
from dwarf lawn jockeys to public park monuments i figured that
 somehow in spite of everything in romania it would be all right

wed just driven down on a grey december day from a conference on
recent american poetry that jacques darras had organized at his
university in amiens where most of the talks were by french scholars
and poets but hed also brought over a bunch of american poets and
arranged a reading for us at the museum of french american
cooperation at blérancourt an old estate that once belonged to jp
morgan and had been turned over to the french government sometime
after the first world war whose battles had left shell scars on the walls
of the older buildings

 there were six of us poets who were going to read and we were
joined by serge fauchereau a well known french critic translator and
anthologist of american poetry who was going to produce part of the
introduction along with jacques

 so with only about twenty minutes of time available i figured id
read a couple of short written pieces because it was not the time or
place for a talk poem so what could i do

 with all the others i had walked in the cold december rain over the
weirdly topiaried gardens that reminded me of alain resnais' *last year
at marienbad* id examined the strange collection of paintings
mostly by minor american painters whod happened to spend time in
france

 id seen the dark green first world war ambulance displayed like a
found object in one of the halls id read the walt whitman poem to
france on the occasion of the franco prussian war that was displayed in
one of the glass cases and i figured ill do the best i can

talking at

blérancourt

. someone asked me once a simple question an absurdly
simple question and i gave an absurdly simple answer whats an
artist he asked and i said somebody who does the best he can by now
ive said this so many times ive begun to believe it because when you
think about it there are very few people in this world that do the best
they can

you know if general motors makes a lemon of a car its
your problem but if an artist makes a lousy artwork its his problem
or her problem so it turns out that artists are the last people in
this world who have to do the best they can because their life is at
stake you say you know a plumber who does the best he can i say
hes an artist you know lots of artists who dont do the best they can?
its very simple theyre not artists anyhow thats how i answer
the question because up to now thats the best i can do for an answer
now as a poet thats the term i get stuck with

i actually choose it
fairly aggressively i choose it in spite of the fact that i tend to feel a
little uncomfortable with it because if im going to be a poet i want to
be a poet who explores mind as the medium of his poetry not mind
as a static thing but the act of thinking and the closest i can come
to the act of thinking is the act of talking and thinking at the same time 49

the closest i can come to my thinking is by talking myself through
it talking my way through my thinking thinking my way through
my talking

 a little while ago jacques asked do we have the right material here
and maybe he was talking about the tape recorder but thinking
about it in general i suppose theres no such thing as the wrong
material were in a museum here a small museum of french
american friendship and museums have a strange effect on me and this
museum like any museum

 but in this museum even more so
because its a small museum

 looking at the pictures on the walls
theres something arbitrary about a museums relation to artists
its a little like looking at driftwood on a beach the artists are
cast up on the shore after the ship has gone down and theyre
carried some distance by the current and stranded on this particular
beach where they get found and hung on the wall trophies of a
random rescue

 museums do the best they can and i suppose i repeat myself but
my sense is that museums are to artists as anthologies are to poets as
zoos are to animals and its hard to think about animals in a zoo
where the animals are sleeping while the people are buying ice cream
and t-shirts and toys its even hard to look at artworks in some
galleries but i got used to it because i had to act as an art critic
which ive done for a large part of my life and i had to find a way to
do that and live with being an artist a poet at the same time

 now the way that i managed to do it was to speak as one artist to
another and anyone else who cared to listen so if anyone wanted
to eavesdrop they could but i wasnt writing for them and if they
didnt want to listen it was all right with me but what i had to say

seemed to amuse a lot of people and the magazines printed it even
 though i was lousy about deadlines and at one point i was told by
donald droll a friend of mine who ran the fischback gallery that a
german magazine with a remarkable name *das kunstwerk* wanted
to talk with me about becoming their american correspondent and
writing about the art scene in new york id already been writing a
new york chronicle for a danish magazine called *billedkunst* so i said
okay donald what are they interested in donald said the editors
are coming to town next week theyll take you to an expensive
restaurant and youll find out when you see them

 the next week two well-dressed germans appeared at the fischback
gallery and they told me all about art they told me all sorts of things
and for someone who understands german very well i didnt know
what they were talking about they were talking about valuable art
 expensive art mind boggling art and censored art they wanted
me to write about important art about art that was winning art
that was losing and art that was important

 look i said i dont know about all that i go around to galleries
 to artists studios to museum shows i think about what interests me
and then i write about it is that all right with you they looked
disappointed they thought i would give them something definitive
and i would have liked to give them something definitive but i didnt
 know anything definitive i go to galleries to see whats there and
sometimes its all right and sometimes its not sometimes im
 depressed most of the time its just not interesting but dont get
me wrong sometimes there are wonderful works its just not
 often but i keep going around i do the best i can even though i
hadnt developed my definition yet i did the best i could and it was
 one of those years it was a year when a great number of my
friends were showing things things i could think about

it was winter and there was a sculptor an englishman an
english sculptor a charming man as elegant and handsome as
general wavell or ronald colman an evasively intelligent slim and
moustached man who was coming to have a show at the fischback
gallery and the opening was set for a friday in february and id seen
a couple of the works earlier my friend donald had shown them
to me

they were small molded plastic shapes about the size of a large
door handle they were white and shiny little organic shapes and if
you picked them up they looked back at you blankly throwing back at
you a dim reflection of your face they were constantly rejecting
they had a kind of enigmatic fascination in their refusal small as
they were to be lovable

thats the way they looked in the back room because thats where
you see a lot of the art before its lit and set on the stage when youre a
working critic they take you into the back room before the lights
are up and the orchestra plays so to speak because they hope youll
review it before it opens but thats how theyll show it to you
anyway even if you cant

so i went into the back room and saw these little enigmatic shapes
and i was waiting to see what they would look like when the show finally
opened wondering whether you could still see your reflection when
they were under plexi when the lights hit them the gallery was
planning a big opening the sculptor had come all the way from beirut
where he was teaching at the american college and there was a
picture of the american college in beirut in the *new york times* with a
short article about the sculptor the day before the opening the day of
the opening new york had one of the worst snow storms in its history
four people came to the opening elly and me and marilyn fischback

and donald droll and the snow lingered and because nobody knew

him and nobody could be charmed by him at the opening nobody
came to see the show with its snow colored little sculptures and it
was not reviewed and the elegant sculptor went back to the american
college in beirut and never appeared in new york again

now as an artist he was no worse and he was a lot better than
many artists who appeared again and again but what was i to write in
das kunstwerk that these brilliant hard white plastic sculptures had
been caught in a storm that buried them like a deluge of styrofoam and
the sculptor had disappeared into beirut would anyone have cared
could i have written sufficiently eloquently in german for them to
understand about the pathos and the loss of the show to him who
would never come back to new york his two years of work gone or
to us who would have to give up the possibility of finding meaning
in those tough little white shapes but you know it was like that

new york was filled with excitement and disappointment yet thats
not what they wanted me to write about they wanted me to write
about important art about artists we knew would come back to new
york again and again and i was a working critic and mostly thats
what i wrote about the scene

and i got started writing for it because an old friend nico calas had
persuaded me to he introduced me to lita hornick so i started my
art writing by taking over the art chronicle from frank ohara for her
magazine *kulchur* and then john ashbery whod published one of
my first art essays in *art and literature* came back from paris to help
edit *art news* where he persuaded tom hess to publish more of my
essays so i was very much a part of the new york art scene from about
1964 on but after a few years i was beginning to get a little tired of it

so john whod become a good friend and something of a comrade
in arms at *art news* decided to help me john decided to help me into
a kind of curatorial career he knew that jerome robbins wanted to

organize an exhibition for the education and edification of his dancers
and john decided i was the one to do it so he provided me with an
introduction to robbins

like many new york poets i was an aficionado
of dance so i knew of the man i knew that robbins imagined himself
as a kind of choreographer diaghilev diaghilev had been a formidably
cultivated man whod taken it upon himself to educate all his disciples
of the ballet russe in all the arts he would drag nijinsky and fokine
to contemporary painting exhibitions to concerts of modern music
to poetry readings and in this way he brought together people like
fokine nijinsky massine and karsavina and spessivtzeva with painters
like picasso and braque poets like apollinaire and cocteau and
composers like stravinsky satie or ravel and robbins wanted to drag
his dancers into contemporary art in the same way jerome robbins
was an american and he was not a diaghilev he was a choreographer
who wanted to be a diaghilev but knew he wasnt so he needed
somebody to help him be diaghilev

so john arranges it and i go to meet jerome robbins who is a
little imperious man "what" he asked me as soon as i walked in "do
you think of paul cadmus" paul cadmus was a perfectly competent
gay painter who specialized in representations of winsome academic
male nudes in 1967 he was about as contemporary as tchelitchev
i told him i never thought of cadmus

"so what kind of show would you put on" he said and before i
could answer he said "let me show you my space" and got up to
lead me there in fact he didnt get up he shot up and started
walking from the room in fact he bolted from the room and he
wasnt walking he was loping he was moving very quickly in what
was almost a half run disguised as a walk

now i am not inordinately

sensitive to one upmanship but it didnt take much effort for me to
realize he was moving so fast that unless i wanted to join in his
masquerade id have to jog to keep up with him and i was not about
to play his game so i set out at a very leisurely pace and ambled into
his dance space a good thirty seconds after him where i found him
seated on a high stool from which he snarled at me

"so what would you show my dancers?"

now you have to remember this was 1967 or so and most of my
friends were minimalist sculptors so i suggested i wouldnt show
them things i would get artists like robert morris or carl andre or
don judd or ronny bladen or sal romano or walter de maria to confront
them with things obstacles over and under and around which they
would have to work because i didnt see art then as so much showing
things as performing i said i would put on a show for them that
didnt look like art but would be the most interesting art by some of the
most interesting artists of the time

now you have to understand that jerome robbins had led me a
chase into his dance space he had seemed to be walking but had
actually been running in order to force me to struggle to keep up with
him and i had realized this and stubborn person that i am i had
sauntered after him so that he had to wait nearly thirty seconds for me
to arrive and he had asked me about paul cadmus and i had proposed
minimalist sculpture so in a state of rage he pointed to his pristine
dance floor and demanded "how would you do that" and i answered
"right on the dance floor id get everything else out of here and fill
up the place with all the junk that was needed for your dancers to
have to dodge skip jump over or be tripped by so your dancers
could encounter the real world they live in" this didnt sound like
diaghilev and needless to say i never did the exhibition

so you can see i had a real relation to the contemporary art

scene even if it was equivocal and i suppose i wrote equivocally
about it sometimes about the people everybody knew and
sometimes about people very few people knew and sometimes about
ideas that were going around in it that i wanted to think about

so i wrote a piece called "pop—a few clarifications" for *das
kunstwerk* and they seemed to like it because they eventually
published it and sent me back a copy of the magazine whose contents i
dont remember all i remember was its cover a remarkable black
and white photo of a soho rooftop with three young people sitting there
and there was something haunting about this image of the three of
them stranded in this unlikely space the two artists and the actress i
recognized as delphine seyrig the incredibly beautiful star of alain
resnais' *last year at marienbad* who in robbe-grillets script was always
stranded between two men and a past and future she couldnt reconcile

now mostly what the art magazines want are essays that promote
the importance of whatever is going on at any moment in the art world
by promoting the artists and exhibitions that galleries and museums
happen to be staging at the time which is why galleries and
museums advertise there to create the impression that theyre
participating in a world in which so much of so much importance is
happening when in reality very little is usually happening

and to help give shape to such an impression museums often
reshuffle the artists and artworks they usually exhibit or have seen
other museums or galleries exhibit into theme shows that the
magazines try to address with "think pieces" that attempt to
articulate the "issues" these shows are supposed to illuminate

now *art news* was at that time a serious magazine that in
addition to the usual promotional activities conducted by all the art
world publications printed serious essays on art and tom hess
who was its publisher and editor-in-chief was a sensitive and

intelligent art critic who was close to the artists he admired and had
recruited his reviewers and essayists from a wide range of contemporary
poets and art historians and he encouraged me to take on one of
these theme shows

it was an expensive and extensive show put on with a large
fanfare by the museum of modern art in new york and it was i suppose
intended to address the current interest this was 1968 of young
artists in new technologies but the museum of modern art was a
historical museum devoted to a particular history of modernism and
its continuities so the show was a historical show curated by a man
named pontus hulten who was something of a stuffed owl a scholarly
gentleman not too familiar with really contemporary art and much
more comfortable with the interests and art of the early twentieth
century so the show turned out to be an exhibition of old art and
old technology and was almost inevitably called "the machine" while
the technology of the second half of the twentieth century was more
about information processing and control and transmission devices
about computers and masers and lasers and usually led to variously
high tech sculptural installations that tom who was much more
committed to the career of serious painting wasnt really familiar
with or interested in so he may have overvalued the show and
thought i should do a think piece about it

but for me it was old technology and old art so how was i to
address it i did it by inventing a machine which in a fit of modesty
i attributed to jean tinguely a machine an information processing
machine i designated as a *self stabilizing data processing device* the
novelty of which was that it was able by means of successive passes
through a series of analyzer banks garble heads and erase heads to
render all new data submitted to it identical to the data already in its
memory system what you knew before you know now and i

presented the patent application for *jean tinguelys new machine* as an
introduction to my essay preceded by a functional input output
diagram of its manner of operation the form of which bore an odd
resemblance to the ground plan of the old museum of modern art but
the application was composed in the prose of patent language and the
resemblance seemed to have slipped by nearly everyone who read
through the accumulation of technological shaggy dog stories that
formed the body of the essay it slipped by my good friend tom hess
and harris rosenstein who edited the essay and i suppose believed
along with everyone else that there really was such a tinguely machine
that i was simply commenting on

of course tom probably didnt care very much and merely enjoyed
the stories while harris may have been suspicious because he was
an all around new york intellectual the kind that probably doesnt
exist anymore a rumpled shirtsleeved chain smoking dedicated art
world professional who would care more about the meaning of a new
rothko painting or a morton feldman composition than a subway strike
or a collapse of the stock market and knew the arts as well as most of
the writers whose essays he edited though he never published a word
of his own but edited all of us for years but he never said a word to
me about it at the time

then suddenly *art news* was sold and fell into the hands of idiots
and not long afterward charming gallant tom hess died and the
old *art news* team disbanded betsy baker went to take over *art in
america* john ashbery went off to write an art criticism page for
newsweek and harris rosenstein went off to administer for the de
menil collection in houston

it was hard to imagine harris and sheila in houston stranded on
the coast of texas near galveston in a raw redneck town with a couple

of great museums a city of flimsy woodframe houses strung out

around a tiny downtown area where a few tall glass and steel
 buildings huddle up against each other like gaunt pioneers seeking
shelter on a windy plain and overhang a cavernous underground space
filled with chic boutiques and stylish eating places to which sleekly
dressed men and women from the corporate world of the tall buildings
 come to lunch and browse and shop but which emptied out by five
oclock leaving nothing behind but dioramas of impeccably tailored
 silent manikins blindly offering on gracefully outstretched arms to
the vacant corridors the jeweled accessories of a perished dynasty
 seemingly destroyed by something like a neutron bomb
 but visiting houston several years later i was there for some sort
of occasion a conference or symposium of some kind held in one of
the tall downtown buildings that brought me and my friend sheldon
 nodelman to houston that year i took the occasion as an opportunity
to visit the rothko chapel which id never seen and the de menil
 collection and naturally we went to visit with harris and sheila to see
how they were holding up in houston and they seemed to be holding
up pretty well under the circumstances of being stranded in houston
harris was handling the publications of the de menil collection which
included nursing sheldons great book on the rothko chapel through an
endless series of deepening revisions and expansions and sheila in
spite of all odds had turned the de menil bookstore into a kind of
cultural oasis for concerts and readings so that nearly everyone who
had anything to do with contemporary art who passed through
houston connected with them
 so we had dinner with them a whole bunch of us went off with
harris and sheila to an improbably distinguished chinese restaurant in
a seedy part of town far from the glass and steel center where our
hotel was located and it was a kind of new york occasion with lots
of noisy esthetic arguments was rothko a colorist even if he denied

it were his brightly colored paintings intended to be "beautiful"
how black were the chapel paintings were they "beautiful" what
about the recent fashion in performance art and were we finally
 through with technological art or would it recur as regularly as the
colored leaves of a northeastern autumn and in the midst of this
conversation harris reminded me of my tinguely piece

 "you know" he said "the fourth time i read it i realized it was
terribly funny"

 the night got later and we descended into the obligatory personal
chronicles who was sleeping with whom now that whoever was no
longer with whom but with whomever else and finally sheldon and
i took a taxi back toward our hotel and as we came out of the
neighborhoods of small houses and two story buildings with store
fronts and drove into the central space of the slim tall buildings the
streets that had been sparsely peopled before became completely
empty and silent as though vacated by something like a neutron
bomb and as we were driving through the narrow canyon between
the glass and steel buildings out comes a small black barouche about a
block ahead of us drawn by a white horse with a little plume carrying
a formally dressed man and woman it travels another block turns a
corner and disappears "sheldon what was that?" "what?"
"the black carriage the white horse" "i didnt see anything"

 a year or two later sheila died of lung cancer i guess all that
chain-smoking finally got her and harris was really stranded on the
coast of texas near galveston but he held together for about another
year till hed finally nursed sheldons great rothko book through the
press and then harris also died

elly and i got persuaded by a couple of young artists teaching there
to spend a week in residence with the art department at the university
of colorado at boulder

boulder is an ungainly little town perched awkwardly on the
continental divide with little to recommend it but a good bookstore a
pleasant university and a magnificent sky and nothing would have
persuaded me to spend a week there except the rare chance to perform
back to back with eleanor on the same program aside from a small
seminar and some meetings with students we didnt have too much to
do before the performances and we spent a lot of time reading but i ran
out of books so i had to resort to the bookstore where i stumbled
on osip mandelstams memoir

the noise

of time

i suppose most people know that when i come to a place i have a
bit of difficulty trying to say precisely what im going to be doing so i
dont start with large introductions but as usual ive got a number of
things on my mind when i go places and i think about them out loud
in public and because what im doing is entertaining ideas not people
im quite happy for people to feel free to get up and leave whenever
they stop finding this entertaining and thats how i know im a poet
not an entertainer though on several occasions people have compared

me to entertainers like lenny bruce but thats not what im like im
not very much like lenny bruce if im an entertainer at all

i admire lenny bruce and have great respect for what he did but
lenny bruce worked in clubs where he had to take on drunks and coax
and coerce them into thinking about something more than getting laid
while he kept them from getting out of the chair and hitting him or
running away the difficulty is that hes there in that space where hes
got to be entertaining even when he doesnt want to be in my case
i always imagine i should put a sign over the door that reads ABANDON
ALL HOPE YE WHO ENTER HERE so that we could begin in a
reasonable conversational way now recently ive been in a kind of
conversation with a number of young artists and what weve been
trying to figure out is what is a good way to think and talk about art
and it seems that art has recently been accused of having ideas

i know
theres also a large contingent of people for whom art has no relation
to ideas and exists only to express emotions but that idea is so stupid
its hardly worth thinking about at all

at the same time there are very serious and intelligent people
who see an artwork as a container for ideas something like a
suitcase or a blackboard on which the artist has inscribed in a more
or less idiosyncratic script a message they could read out once theyve
deciphered the handwriting so they study the handwriting and
when they think theyve got it figured out they declare that this
artwork says this and thinks that and they arrive at this notion
because they believe that artists as relatively intelligent people having
intentions and opinions declare them in their artworks like a traveler
passing through customs

i realized id never thought about artworks this way and i
wondered whether or not it was at all reasonable to think so and

around this time i happened to read something that made me think of
 this idea again id picked up a copy of the *nation* in the bathroom
we keep our copies of the *nation* in the bathroom its a magazine we
 like to read when were otherwise occupied because it has amusing
political conversation though its otherwise totally absurd but it
 also has one intelligent person who writes about art a very
cultivated and eloquent writer most of their other reviewers are
 worthless their film reviewer is silly their literary reviewers are
ridiculous but they have an art writer named arthur danto who is
 an educated and sympathetic critic of contemporary art and he was
writing a commentary on an exhibition by robert morris his
 retrospective at the guggenheim morris is an old friend of mine
and as a result although i no longer like to write formal art essays
 i had been persuaded to contribute an essay to the catalog and
because of currents of cliché in the contemporary art world i realized
 this exhibition was going to run into a generally unfriendly press
so i was curious to see what arthur had to say

the essay was disappointing it was only mildly affected by the
negative currents of fashion but didnt get very far in talking about
 morris at all but in the course of the essay arthur quoted apparently
with approval a statement of hegels from the *aesthetics* a kind of
 sweeping statement you dont usually find quoted in art reviews
which made a remarkable claim that an artwork is the embodiment
 of some truth

now im not entirely sure what in this context would have counted
for hegel or for danto as a truth and im not sure why we couldnt
 with equal confidence consider it the embodiment of a lie for which
 theres a great classical tradition in all those smooth bodied statues of
young greeks and noble roman emperors and all those paintings of
 complaisantly luscious courtesans and handsome warriors but this

doesnt really answer the question of what an embodiment either of a
truth or a lie might really be

 it seems to imply at the very least that an artwork can be created
as the physicalization of a very unphysical thing an idea and
while there may be some difficulty in deciding exactly what an idea is
 the real problem i had with this claim was that i wasnt really sure how
an obdurate object like an artwork could be the physical manifestation
of something as abstract as an idea

 now my first thought was that christians might understand this
 for christians jesus figures as the embodiment of an idea of god yet
even for them this is a bit confusing because sometimes jesus is shown
 exercising divine powers doing miracles here and there casting out
demons raising people from the dead but at other times his body
and even his spirit appear to suffer all the pain and anguish of being
human and abandoned on the cross and of course jesus is no more
 like an artwork than any other human being because his creation
according to most dogmatic accounts is effected by human though
 miraculous means and this has been confusing even to orthodox
christian theologians so it should be no surprise that personally i find
it totally absurd but interesting and up to now its been the closest
id ever come to understanding the notion of the embodiment of an
idea

 but of course i never really understood it i never understood
how anything as tangible as an artwork could embody anything as
intangible and singular as an idea or a concept or a proposition or
even a sequence of propositions though now that i think of it
 maybe
i can imagine a kind of example something that comes close to it
maybe an artwork thats a kind of machine a machine has a sequence

of parts that are functionally related to each other like a series of
propositions and you can follow them from part to part from
 an initial supposition to a determined end like a mousetrap a
mousetrap is a simple machine its simple and lethal its there to
kill mice and it works in an elegant way it consists of four basic parts
a base a killing engine a bait platform and a restraining bar
 the base is simply a rectangular piece of wood the killing engine
is an assembly consisting of a rectangular loop of metal wire anchored
by one of the shorter legs to the center of the wooden base where
the short leg acts as an axle for a spring thats slipped sleevelike around
 it pinning the opposite short leg of the looped wire down to one end
of the wooden base the restraining bar is a straight piece of metal
 wire attached longitudinally by a loop at its end to a small metal hoop
anchored at the other end of the base and the bait platform is a small
cantilevered piece of plastic or metal mounted on an axle situated
toward the center of the wooden base and within the pinned down
 wire loop in such a way that it can pivot up and down like a seesaw
 for the machine to be set to work some peanut butter is smeared
on the bait platform the metal loop of the killing engine is pulled
back down to the other end of the wooden base and pinned in place by
 the restraining bar the end of which is laid over it and hooked under
a projecting element of the near leg of the cantilever elevating the
bait smeared end of the platform which is held in place by the
restraining bar under pressure from the spring exerted upon the short
leg of the wire loop which is reciprocally held down by the
restraining bar all thats required for the machine to work is the
mouse
 a mouse is drawn by the smell of the peanut butter approaches
 the bait platform and tries tentatively to lick the butter in doing so

it rests its head lightly on the raised end of the bait platform and
 this slight weight depresses the bait end of the platform pushes up
the other end of the seesaw and frees the restraining bar which
 explodes upward releasing its downward pressure on the wire loop that
the spring slams down on the mouse and breaks its neck in theory
 anyway and the theory is an exercise in logic

 if the mouse is drawn to the bait it tries to eat it licking the
peanut butter depresses the end of the bait platform if this end of
 the cantilevered platform is depressed the other end is elevated if
 that end is elevated the restraining bar is released if the restraining
 bar is released the spring driven wire loop is forced up and explosively
down onto the neck of the feasting mouse so the mousetrap is a
 chain of successive implications embodying a single truth desire
 leads to death at least from the point of view of the mouse

 but even from that perspective there are some uncertainties in
the chain of implications first there is the question of the bait i
 dont pretend to be a zoologist but ive conducted numerous
experiments and in my neighborhood there are two classes of mice
 peanut butter mice and jelly mice peanut butter mice have no desire
for jelly and jelly mice have no desire for peanut butter this will not
affect the theory but no mouse will come to the trap if i put out the
wrong type of bait then there is the question of dining style a
 fastidious mouse may not rest its head upon the platform while
delicately licking up the peanut butter or jelly the platform will not
 be depressed and the mouse will have its banquet in peace this
might suggest that the mousetrap embodies a quite different truth
like manners are a life and death matter or refinement can save
 your life

 but there are other variables that affect the unfolding logic of the
mousetrap a clumsy mouse might jostle the wooden base with its

paw knocking the restraining bar loose and springing the trap without
ever entering it

 with the trap sprung the mouse can feast at leisure
the truth this suggests may be god looks out for fools sometimes
 but then there are still other variables we live in california
surrounded by geologic faults rock shelves move along the fault
plane the earth shrugs lightly and the trap is sprung the truth
 no machine is fault free but this truth is manifested only occasionally
and then the fault may be in me i may fix the restraining bar too
firmly under the bait platform and it may never spring or too loosely
and it springs almost immediately or the mouse is frightened and
moves quickly back so that only its paw is caught in the trap and
then i pick up the trap and set the wounded mouse free in the canyon
in back of the house

 but these are all practical imperfections that can occur in the
working of any machine and i suppose we have to look for the idea
the intention of the machine as embodied in its form the way we
look at a vito acconci kinetic sculpture which rarely works but lets
 you figure out how it would work if all other things were equal still
theres nothing in an acconci machine that suggests a logic as
remorseless as a mousetrap which unfolds like the plot of a story
 so i suppose if you imagine an artwork thats built like a story
but i cant think of many artworks that are very much like a story
and even in a story it is a serious question whether the logic of its
unfolding plot is the only or even the main meaning of it but this
chain of events seems to mirror a sequence of purposes and actions
intended to fulfill them and this movement from an intention to an
end seems too single minded and purposeful for most artworks i know
 in fact i cant think of many artworks aside from leni riefenstahls films
and roman imperial sculpture that are as goal oriented as this so

maybe an artwork is not at all like a mousetrap maybe it doesnt
embody any ideas at all maybe its more like a bowling ball that you
roll toward ideas you know the ideas are out there somewhere
and you roll this bowling ball toward them and it knocks over some of
them and leaves other ideas standing or leaning against each other
and i thought maybe thats the way it works thats so wonderfully
clear but i guess it depends on what kind of bowler you are

i think i should point out that ive bowled only twice in my life
and while I loved the setting i hated the sport half the time my ball
went down the gutter at the side of the alley and missed all the pins
but my incompetence aside maybe people are less purposive when
they make artworks and a bowling alley is all purpose the pins are
all stacked up neatly in front of you and the alley leads straight to
them you pick up the ball and look right at the pins a bowling
alley is all intention how often have you seen a bowler pick up the
ball and roll it in another direction

now as an artist ive never felt so purposive that it seemed i was
looking down an alley at a bunch of ideas i wanted to knock down
sometimes i felt like ideas were running in all directions and some
of them were running by me and i was tempted to stick out my foot
to see what might happen but it never felt as if i was leaning
forward so directly into my intention

still there are ways in which an artwork can be addressed to doing
some particular thing formulating a paradox lets say that might be
something like sticking your foot out into the smooth flow of traffic

but theres another way in which you could make an artwork that
would be something like the construction of a narrative a narrative
not a story because i distinguish between narratives and stories
this is a distinction of which aristotle and the french critical tradition
as well as the american folkloric tradition are all ignorant because all

theyre interested in is plot and as i see it a story is all about plot a
story is the representation of a series of events and parts of events
 that result in a significant transformation its a logical form but a
narrative is a representation of the confrontation of somebody who
 wants something with the threat and or promise of a transformation
that he or she struggles to bring about or prevent or both these are
 two different cognitive modalities addressed to the problems posed to
us by time because time is measured by change and change
destabilizes all things especially human things because we are all
temporary steady state systems who like to have to think of
ourselves as stable in order to imagine ourselves as selves at all

 and theres only one philosopher i know whos thought about
narrative this way and thats paul ricoeur when hes in his augustinian
mode but then he falls back on aristotle and gets too involved with
plot and thats story not narrative from my point of view because
while narrative is usually encountered on the inside of story the two
modes do not require each other and each one can appear pretty much
alone there are stories without narratives in every newspaper in the
country a hurricane swung inland and hit the coast of florida once
there was a peaceful town called tallahassee and now its in ruins you
lay out the before and after with all the demographic and sociological
detail you like and youve got a story without a narrative and there
are narratives without stories plays like *endgame* or *waiting for
godot* or in a more extreme case the wraparound paintings of rothkos
houston chapel where the viewer can only struggle to see the
paintings on the walls in front of him and try to relate them to the
difficultly seen images of the paintings in back of him that hes
desperately trying to hold stable in his mind while all the paintings are
subjected to changes in color and figuration by minute variations in the
natural lighting every time a cloud passes overhead or to changes in

the viewer who would like to believe that hes not changing in spite
of the near inevitability of changes in his perceptual state and mood
occasioned by the duration of difficult viewing this is what ricoeur
saw as the center of narrative the human mind confronting what he
called the aporias the blind alleys of time

but why do we want to represent it why does anybody represent
to himself or herself the struggle for and against transformation and
the answer may lie somewhere close to the anxiety produced by the
paradox that however much we are tempted by transformation the
beggar would always like to become a king but this change courts the
danger that the beggar could be lost in the transformation and merely
inherit the kings troubles without any memory of the satisfaction of
the obliterated beggars desire

or maybe it lies closer to the terror of absolute erosion that can
be forecast by even the most minute changes in our lives

so its the loss of experience that were struggling against and the
loss of the self in the increasing unintelligibility of our lives that is
produced by time and today i was walking in the mall and we went
to a bookstore and i bought a book that i was attracted to only by the
title although its a beautiful book by a very good russian poet named
osip mandelstam its a book called *the noise of time* and the name
resonated for me in a way that went beyond mandelstams lovely essay
of that name on the lost petersburg of his childhood and got me started
thinking about all these things

there was something in that name *the noise of time* that
fascinated me in a way i didnt think it was possible for mandelstam to
mean though what he meant by it wasnt entirely clear even to
clarence brown the excellent translator of the book or rather
brown sensed what it meant but wasnt quite sure of the best way to
translate it and in the introduction he gives an elaborate description

of the reason for his choice of *the noise of time* from a great variety of alternatives

the name mandelstam had given the essay in russian was *shum vremeni* the second part is easy it means "of time" the question is what exactly *shum* means if you look in a russian dictionary it can mean the rustle of leaves the roar of the sea the pounding of the surf the buzzing in your ears the clamor of a crowd the drumming of rain the racket of traffic or more neutrally the sound or noise of any of these bundles of continuous repetitive percussive and abrasive events

the translator cites all these and adds one more an astonishing translation provided by vladimir nabokov in his weird version of pushkins *eugene onegin*

nabokov was a formidably educated if eccentric linguist with a poets superb knowledge of his native language and the translation he offers for *shum* is "hubbub" in what must be one of the funniest lines ever to show up in a poem in english "morns pleasant hubbub has awoken"

only a comic genius like nabokov could have produced a line like this where "awoken" is just about as funny as "hubbub" which he comments on in a lengthy deadpan note that provides not only an extensive consideration of the onomatopoetic career of *shum* in all its morphological forms but also an almost equally wonderful line of pushkins containing the word *shum* which he renders as "morns frisky hubbub has resounded" and "frisky" is almost as good but "resounded" cant compete with "awoken" yet in spite of all these wonderful suggestions i think i can understand why clarence brown chose to go with *the noise of time*

clarence brown translated this work in 1963 or 64 just about the time that works like claude shannons book on communication

theory became part of general culture this book and many works
like it extended the meaning of "noise" to entropy the growing
disorder that affects all ordered systems over time the frictional
forces that reduce all directed energies to forms of disorder sooner or
later as we go from more orderly universes to more disorderly universes
given enough time

working in the sixties brown must have sensed this though he
may not have been aware of it when he made mandelstam the gift of
this brilliant new meaning of the word "noise" a meaning that
mandelstam benefited from but couldnt possibly have known or
intended when he wrote *the noise of time* in 1928 just ten years
before he died in one of stalins prisons

time does strange things to you its a bit like the ocean
mostly it takes things away but it also casts things up on the beach
new things or old ones from different places now looking very
different every bit of disorder contributes to the formation of a new
order usually worse but sometimes better

you lose a lot and you may win a few maybe in the end you
lose it all but meanwhile some disorder may be good for you even
if you dont know it

i was sitting in oklahoma city in a diner having lunch with leo
steinberg and we were eating potato skins with two different kinds of
gravy because oklahoma citys cuisine is distinguished by thirty kinds
of gravy and very little else we had just given talks at the oklahoma
city museum of art a pretty little beaux arts building complete with
a porte cochere perched perilously over an oil well that the trustees
periodically threaten to open up whenever theres a shortfall in their
operating funds or a sharp rise in oil prices

now leo is not only the most elegant art historian i know but he

is also distinguished in his profession by having the most extraordinary
admiration for artists maybe even an exaggerated admiration for
them and since he had just given a talk on picasso an artist upon
whose genius he had reflected brilliantly for a very long time our
conversation over potato skins swung around to a more general
discussion of the mysterious nature of artistic genius which isnt a
subject about which i ordinarily have much of an opinion

but in the course of the conversation leo quoted a line of
shakespeares that he regarded as a distinctive mark of his poetic genius
it was certainly a remarkable line and its distinctive in many ways
its from *measure for measure* and i think it goes "his head sat so
tickle on his shoulders that a milkmaid might sigh it off an she had
been in love" and its a pretty sardonic comic line coming as it does
at a dark moment when the hero is in real danger of losing his life
but what got leo was the word "tickle"

"tickle tickle nobody but a great poet could have written
that" up to then we were in agreement about it being a remarkable
line but at the word "tickle" we parted company i agreed it was a
pretty startling word it stops you for a moment when you read the
line and shakespeare was a brilliant poet but he was also a
workmanlike if equally terrific playwright and it didnt seem to me too
likely he would expend his energy on inventing an entirely new usage
for a single word that could easily be misheard in a line of a quickly
written play somehow it didnt seem too likely and somehow i felt
that if he was a genius that wasnt the way his genius worked

so i said come on leo i dont really know but i bet there were
dozens of elizabethan uses of the word "tickle" that simply meant
unstable or precarious thatve just disappeared or maybe its a misprint
for fickle or maybe its a cognate with fickle

but maybe its not maybe its just a normal word used in the
ordinary way you would refer to a ticklish situation without suggesting
the feeling of being rubbed lightly under the arms

but we didnt agree because for leo i think a great artist is like an
isolated mountain peak dominating the surrounding plain and for
me a good artist has got to be very ordinary and a great artist is just
more ordinary than everybody else so we left it at that but when
i went back home i looked at the big oxford english dictionary and
sure enough i found a late fifteenth century text that described rocks
that stood so tickle in a stream they rendered passage perilous
because you could fall and break your neck and i was about to write
this to leo when i thought no i dont want to write this to leo
why should i do that the noise of time had drowned out all the
other ordinary uses of tickle and left shakespeares line alone a
brilliant stone thrown up on the beach why should i take this gift
away

so you dont know what time will do it can stick a feather in
your cap or take it away the feather may be blown out of the tail of a
pheasant caught in a whirlwind and land on your hat but you never
know whats going to happen

still we struggle with time we try to come to terms with its
transformations that undermine our understanding of our being
because time is at war with being all the time

and thinking of the separations of things the separations of
things affected by time i think of the way generations are separated
by time

like my son who elly and i are very close to he grew up as an
art kid the kind of kid who was at home with all kinds of art because
he grew up with it hes four years old and were driving along the
freeway and hes getting bored because were talking to each other not

to him and hes sitting in the backseat suddenly he lets out a
scream

"look im chris burden" and dives headfirst into the front seat
between us so i guess we brought him up the right way

and he was not much older than that when we were once again
driving along the freeway through a beautiful natural landscape and
he spots a billboard with a wonderful mountain landscape on it and
he says "look theres a landscape in a landscape"

so we had an art kid when he was four years old but now hes
thirty and hes running a think tank that advises people with lots of
money at stake on whether the lira or the deutschmark or the kroner
will rise or fall and he makes these predictions on the basis of the
political expertise hes been acquiring since he was a kid in the days
when he used to hang out at the university library and study all the
newspapers and elly and i had to bring him back the local papers
from wherever we went to do readings or performances and he
makes these predictions from a certain sense of distance because
although hes predicting these outcomes for people who are profoundly
interested in money and passionately committed to profit he has
relatively little interest in profit and somewhat like an artist hes
mainly interested in the game

so theres a separation of a sort but a connection across it and
we come together in certain interests we share though in different
ways across a space that we understand and it remains a space
though we can look across it

and one of the spaces we shared and looked across almost but
not quite together was the greater space separating him from his
grandfather

ellys stepfather was a man of the nineteenth century at least he
was born in the nineteenth century a hungarian poet and painter

named peter moor whose real hungarian name was barna joszef
whod taken the romantic name moor after shakespeares moor of
venice and my sons name is blaise cendrars after the romantic
name taken by a young swiss boy on his way to becoming a great
french poet so they had something in common across a gap of about
seventy years

 and peter and blaise spent a lot of time together blaise used
to visit him regularly and play tennis with him and its not easy to
play tennis with an eighty-eight year old guy who has elegant strokes
but moves somewhat slowly around the court it takes more effort
than playing a thirty year old because when your eighty-eight year
old partner hits a deft forehand into your backhand corner you have
to take it on the run and return it with only moderate power to a point
no more than one running step away from him so that he can make
a stylish return to keep the rally going for a sixteen year old blaise
was very good at this and at refraining from hitting a full power serve

 he was also good at receiving lectures between games on how to
improve his backhand or forehand in the manner of borotra or lacoste
or henri cochet or other great stars of the distant past

 it was a little exasperating but blaise was good at it because peter
was very charming and could explain to him why kurt vonnegut was
too smart to be a truly great writer or tell him stories about growing up
in a small town in hungary before the first world war about being on
his schools gymnastics team and about the little white peaches of
keckemet that were sweeter than any hed ever eaten the rest of his life
or about prewar budapest and the swimming pool of the hotel gellert
with its artificial waves and the famous candy shop with the most
voluptuous chocolates in all of europe but then he might also talk to
him about the excellences of the poetry of ady or of hofmannsthal or
goethes *faust* and this was probably a little less interesting for blaise

who is a talented writer but has no patience for nineteenth century
poetry

but between peter and blaise there was a real intimacy across the
space of seven thousand miles and seventy years of experience that
separated 1914 budapest from 1980s california an intimacy that may
have been as deep as the gap was wide blaise was sixteen and just
awakening into his sexuality and peter at eighty-eight could look
back from a waning physical being on a long history of romantic
attachments whose image burnt so much more brightly now in the
light of memory and unsatisfied desire now that the last and longest
of these attachments to eleanors mother a beautiful woman even in
her seventies had disappeared with her descent into the abyss of
alzheimers and one thing they probably shared was a sense of sexual
loneliness

i dont really know what they talked about in all the time they
spent together but peter was the first person except perhaps for
blaises closest friend brett to learn of his first real girlfriend so im
sure that peter remembering the temptations and fears of his own
distant adolescence must have offered blaise a mix of chivalric
encouragement and cautionary tales from the experiences of his fin de
siècle youth in one of the great capitals of the hapsburg empire
which is what he must have meant when he said that hed given blaise
some "very good advises" and whatever blaise made of these
"advises" he must have sensed through the intense nostalgia of these
schnitzlerian reminiscences the intensity of peters loneliness and
sexual longing

an eighty-eight year old hungarian poet and painter who had
outlived his contemporaries now living in california surrounded by
people who couldnt speak his native language whose beautiful and
accomplished paintings could find no appreciative audience because

their time had passed without making him sufficiently famous to preserve them a place in the history of either hungarian or american art whose poems could really be understood by no one he knew and blaise was the only one to whom peter could comfortably confide in however masked a form the desperation of his sexual desire and all blaise could do was listen

but peters birthday was coming up and blaise wanted to get him a present he knew that fairly soon he would be going away to college and he wouldnt be able to see peter quite as often and wanted to get him something very special he talked this over with his friend brett and at length they came to a decision the two sixteen year olds decided to find him a hooker

now i only heard of this many years later from someone who wasnt there either but as i understand it this is what happened

they took bretts parents great red cherokee and cruised slowly through san diegos gaslamp district looking for a hooker their plan was to find a girl in miniskirt and boots and too much makeup and arrange for her to encounter peter probably in the supermarket where she would pretend that shed heard he was a great artist and convince him that she desperately wanted to see his paintings and then he would take her up to his apartment to look at the paintings and she would seduce him

this was the great plan and they would pay her pretty well theyd pooled all their money and they had something like a hundred and fifty dollars that theyd saved up they had it all worked out and the only thing they needed to do was find the hooker

so they got into the red cherokee and drove downtown to the gaslamp district where they spotted a woman in a miniskirt and boots they double parked and blaise ran out to talk to her look he

said weve got a job for you and she looked doubtful its an eighty-eight year old gentleman

thats cool she said theyre gentle hes a painter blaise said its ok she said im hip this was 1984 and she spoke in the language of the sixties blaise went on youve got to meet him by accident and pretend you know about him and you want to look at his paintings i dont know she said i dont know about that brett came out of the car to help you dont have to say a lot he said hell tell you all about them and hell probably recite some poetry to you in german blaise added or hungarian in german? she said look they said weve got a hundred and fifty dollars

i have to listen to poetry in german for a hundred and fifty dollars

thats all weve got they said and she thought a while wait she said i think theres a girl i got a friend down there monica you know she works further down the block i think shes german or maybe polish but anyway shes european she could probably listen to that so they tried

two three four five girls in miniskirts and boots and they offered plenty of money or what seemed like it at the time a hundred and fifty dollars but nobody wanted to look at art or listen to poetry for a hundred and fifty dollars this was the gap they were finally unable to bridge in their attempt to recuperate losses from the noise of time

new york was changing when we lived in it we had an apartment in
old greenwich village on cornelia street right around the corner from
the building that housed new directions and the fugazzi travel agency
and in back of the garden of emilios restaurant the apartment was on
the fifth floor of a walk up that was so old it had the remnants of a slave
quarter in back it had a bathtub in the kitchen and shared the toilet
with my neighbor across the hall but it was right across the street
from an italian bakery whose bread you could smell in the early
morning hours it was up the street from a great cheese store where
you could buy unpasteurized stracchino and down the street from a
tuscan fruit store guy who corrected my italian and it had an
unimpeded view of the hudson and the palisades on the other side
 when i first got the apartment in 1957 i paid $18.75 a month for its
princely three rooms and by the time elly moved in with me in 61 it
had a bathroom and shower and we paid $29.00 a month
 meanwhile the rest of the city was changing the old citys
nineteenth century buildings were being torn up for glass towers we
left the city to go upstate for a while and came back in 63 in 64 the
old pennsylvania station bit the dust we moved to california in 1968
and when i came back to do a reading at st marks in 69 the italian
bakery was gone in the late seventies the cheese store was replaced
by a boutique new directions moved up to fourteenth street
fugazzis was gone emilios disappeared along with the used bookstore
carl ashbys frame shop and the florentine fruit vendor so its kind of
comforting to be here at the whitney philip morris across the street
from old grand central station thinking of how

i never

knew

what

time

it was

you probably wonder why i gave this title to a piece since im
generally known for not knowing precisely what im going to talk
 about my titling has often been accomplished by other people calling
my talk something ahead of time and i say that sounds interesting
 maybe ill talk about it but this time i knew i was going to share a
program with eleanor and its very rare for me to be on a program with
 eleanor who i know very well ive watched her perform so many
times but one of the things i know best about eleanor is her peculiar
 relationship to time
 its a very peculiar relationship i have the sense that eleanor
always believes theres much more time than anyone else would believe
 so that if eleanor has to go somewhere that takes about an hour to get
to she will imagine it takes fifteen or twenty minutes and she

regularly starts preparing to get there at a time based on that assumption
but then she always forgets the amount of time it will take her to
complete her preparations taking a shower brushing her teeth
combing her hair choosing her clothes

 simply going to the movies
might require her to try on half the contents of her closet before
deciding on the right pair of jeans or the sweater that goes with it
and by the time half the closet has been emptied onto the bed and she
looks dashing and chic in just the right amount of makeup to look like
no makeup she starts to realize that shes approaching the
moment of departure

 which triggers a set of retreats from the door for a variety of
reasons all of which are extremely well justified its still sunny
outside and may be warmer outside than inside so the sweater shes
chosen that goes so well with her jeans and feels so nice inside will be
uncomfortable outside this produces a return to the bedroom till the
other half of the closet is emptied onto the bed and eleanor returns to
the door in another elegant sweater looking chic and ready to go but
shes forgotten her reading glasses or sunglasses or at least she thinks
she may have forgotten them so she has to return to the kitchen to
dump the contents of her bag on the table and search for them

 eleanors inability to get out of the house approaches the epic
because she always has to confront these anxieties which are always
justified but she always forgets them and always forgets how long it
will take her to get anywhere and so she is almost always late

 now i know that i have my own peculiar relationships to time i
was doing a piece last month or maybe it was only a couple of
weeks ago

 now im not even sure what time it was i was doing this piece

but it was at the museum of contemporary art in los angeles and it
was about remembering it was an exchange piece it was a piece in
which i was going to exchange my stories for other peoples stories
and i knew this was possible because everybody tells stories to make
sense of their lives because the way we make sense of our lives is by
telling stories about them stories which may or may not be true
but making sense and telling the truth isnt exactly the same thing
so when i speak i guarantee nothing i say as truth i do the best i can
but beware
 anyway i decided to structure this story exchange somewhat like
a piece i had done much earlier back in 1971 and thats one way in
which it became a memory piece because i had to remember this
show back in 1971 it was a kind of goofy hypermodern show called
"software" that was put together by jack burnham for an exhibition at
the jewish museum which on the face of it already sounds goofy
but it wasnt as goofy as all that
 the show was looking forward to the progressive mentalization of
art in a computerish kind of way or so its name suggested and
the jewish museum was an avant garde museum in those days that
had put on a variety of important shows by major figures of what was
then for the lack of a better name called the avant garde and jack was
committed to the progressive conceptualization and dematerialization
of art and somehow he decided that i should be in the show and he
asked me for a proposal those were the days when the art world was
talking about art and technology so i designed an elaborately
engineered installation whose only goal was to create a long poem
made up of a chain of different peoples stories all built around a
single obligatory word a kind of narrative exquisite corpse and the
sole function of the installation was to encourage people to tell their

stories and reward them for it afterward by allowing them to hear the
stories of other people who had preceded them followed by their own
story as a kind of last word

but as i see it now my installation was a kind of overkill coming ·
from an engineering background i did an engineering version of it
it was the kind of thing you do when youre a kid the contemporary
world has gone high tech and you want to keep up with it so you
have to use a lot of high tech now you see me here with low tech or
no tech ive outgrown all my technical devices

theyre great toys just
like a rattle and i love them still even if i dont use them anymore and
the piece i designed in 1971 had some of this childish charm it was
like a little house a little three room house with windows

i didnt really
want the windows

the windows were forced on me my idea was to
have you come into a room and hear a voice explaining that you were
about to hear a word and asking you to think about this word and if
you felt like it go into the next room and tell a story preferably a
true story using that word and if you were still interested to
proceed into the last room where youd hear the work you had been
part of

which turned out to be four stories containing the same word
the first three by the people who had immediately preceded you with
your story providing a kind of ending so that each segment and then
the whole tape was a simple kind of narrative an exquisite corpse
made out of different peoples stories built around the same word but
since the first person into the installation would otherwise have had
no stories to listen to jeff raskin eleanor and i each told one

story on each of the thirty-some words on each of the thirty-some tapes
for the thirty-some days the exhibition was scheduled to run and
this was what also made it a story exchange our stories for theirs
 now the idea or the ideas behind this piece were very simple
but the details of design and construction were fairly complicated
and it took a fair amount of time and effort and money to realize them
and it took a long time for me and my friend jeff raskin to plan and
construct the control mechanism and for the smithsonian institution
which was collaborating on the exhibition to construct the housing
for the installation from our drawings
 which were quite precise but
in a manner typical for high powered organizations helping artists in
high tech exhibitions the smithsonian screwed up they didnt take
my drawings seriously in fact they paid no attention to my drawings
and made a complete mess and i had to kick their people out and
rebuild the installation with tools i ran down and bought on canal
street the week before the exhibition opened
 but that was then and this was now this time i figured i would
design the whole work as a simple gift exchange and i was going to
do it in the lowest tech manner i figured id go back to the old software
show take all those old audio tapes i had hours and hours of
audio tapes of the stories people had given me and transcribe some
of them
 id take stories from twelve of the days of the software exhibition
the new installation was to run for twelve exhibition days print
up three stories on each of the twelve words put them all up on the
wall and then i would set up under a card with instructions a simple
little box like a letter drop on a desk with pads and pencils beside it
 and each day the curator or the curators assistants or leprechauns or

brownies would put up on the wall a little card with the word of the
day printed on it a simple word like "balance" "black" or "drift"
words that the instructions would encourage you to use in a story that
you could write and drop into the box on the table as a gift to me in
exchange for the stories i had put on the wall

it seemed like a great idea and because this piece was all based on
remembering an older piece i had done back in 1971 i called it
REMEMBERING: A GIFT EXCHANGE but like a lot of great ideas
based on remembering it came to grief in the remembering

i remembered i had all these tapes all these tapes filled with
stories and i did have them twenty-seven years ago but somehow
they had disappeared so now all these tapes were gone the show was
about to begin and i had no stories to put on the wall but i still had
the word list or part of the word list and i thought i could remember
the rest and i did what any practical artist would have done in my
place i sat down and wrote thirty-six stories on twelve words that i
remembered or thought i remembered from that old list in about
two weeks time

actually i got carried away and wrote forty stories in two weeks
two weeks

there seems to be something meaningful about this number
two weeks is fourteen days in which i was going to recover words
lost from twenty-seven years ago maybe its the temporal dislocation
between weeks and years anyway it all sounds very precise and
meaningful to recover in two weeks what i had lost over twenty-seven
years but of course there was something of an accident in this as
usual the reason i had only two weeks to do it was that just before
my exhibition was to be installed i had to go east to providence rhode
island to mourn for a friend of mine my publisher jay laughlin who
had died rather unexpectedly and now they were arranging at brown

university a ceremonial remembering for jay who had also had a
strong sense of the arbitrariness of duration

in any event i wrote forty stories it turned out i somehow got
carried away with some of the words and i liked them so i wrote
forty stories and i got them printed up to the size i wanted the fax
machines were kept terribly busy between san diego where i live and
los angeles where i dont live and we had to send proofs back and
forth with bigger and smaller print change the typeface alter the
layout darken the print

finally i had all these stories up on the wall and i explained that
this was going to be a gift exchange i was giving them all these
stories and as a further gift i would come in twice during the two week
run of the show and do two talk pieces and their gift to me would
be the stories they would write on the word of the day on the little
pads on the table and drop into the letter box and i figured you
know whats going to happen everyones going to go in there and
theyre going to want to read the stories for their day but not for any
of the others how do i get people to read the other stories how do
i get people to read text on a wall

my stories were very short three lines to fifteen lines maybe
very short stories but the real question was how to get people to
read text in a museum any text people hate reading texts in
museums unless they have a reason to read them so i decided to
make it hard hard but not impossible to find out which word a story
was based on so somewhere in each story the key word was italicized
once you had to look for it but you could find it if you read the
story but i also made sure that none of the stories that were on the
same word could be found right next to each other so you had to go
hunting for them among stories that werent on the same word if you
wanted to find all the stories that were on the same word you had to

go looking through stories on lots of other words if you wanted to
find all the stories on "drift" or "balance" or "car"

apparently my strategy worked people wandered around the
walls of the gallery reading through stories on "grain" and "neighbor"
and "balance" while they were looking for "drift" or "friend" and
they didnt seem to mind because they wrote me lots of nice stories
when they came back to the table at least thats what the curators tell
me because the stories havent come back yet

so i guess i managed to get it done barely and of course the
stories havent come back yet because the curators like all curators
are busy with their next show and they havent shipped anything
back to me yet though they say theyll send it back in a minute and
maybe they will get here in two weeks or three or a month but
it will still feel like a minute to the curators because thats what its
like with time

theres time their time and my time and maybe theres our
time or maybe there are only senses of time different senses of
time all these things happened in a sense of time or in a mix of
senses of time

and i was thinking of my feelings about this when i agreed to do
talk pieces at the museum there to go along with the stories and i
thought i was going to talk about remembering and i wanted to try
to remember what 1971 was like and how in the world i came to the
idea of a story exchange as an idea for an artwork back in 1971

now i believe that what i call narrative which other people call
storytelling is a fundamental cognitive activity without which human
beings couldnt exist at all but thats what i believe now i couldnt
have believed it then or not in that way not in the teeth of received
modernist opinion that narrative and representation were the two
greatest enemies of modernism but i must have believed it in some

way in spite of the classical modernist notions of the futility of
narrative and representation promulgated by that lovely classical idiot
apollinaire

i have a very low opinion of apollinaires intelligence but a
terrific opinion of his ability as a poet i share this low opinion of him
with duchamp who also thought he was a jerk perhaps for different
reasons but basically we stand on the same ground about apollinaires
understanding of the modern but in any event of this particularly
preposterous notion

apollinaire used narrative nearly all the time
but put it down because he thought he should yet what he was
putting down wasnt narrative but conventional narrative and not all
conventional narrative at that he knew as we do that pornography
produces defective narrative and whats interesting is its defectiveness
but this was also something that was not quite so clear to me in 1971
and i kept trying to remember 1971

now how do you remember a date like 1971 how do you
remember any date like the millennium i keep hearing this
bullshit about the millennium who hasnt heard something about
the year two thousand everybodys heard something about it two
thousand from what

look a radical young rabbi gets killed by romans he dies and his
followers who admire him try to remember this and they remember
it was somewhere during passover and they know who was governor
at the time who was the roman governor at the time? then they
have to figure out how old their rabbi was when he died and they
figure out he was either thirty or thirty-three or some other nice
number and they count back from this passover which they try to
locate by remembering the time of this governor whose name they
remember

because if they know the governor then this had to occur
within the governors lifetime and if they can locate this within the
 period of his service in judaea working from what the governors
dates were and the age of their young rabbi they start trying to
 count back they count back and they wind up with a number but
there is another question

do they count back in terms of the roman or jewish calendar
in all probability their rabbis age and the time of passover would have
 been computed by the jewish calendar and the governors age and
term of service would have been computed by the roman calendar
 from which the christian calendar was created

but the jewish calendar has a much earlier first date because it
 was computed from when the world began because jews know
when the world began which was five thousand some hundred
 years ago on one particular day it was like the big bang the
world began all of a sudden though it took seven days to finish the
job or maybe it was six because nothing happened on the seventh
except rest unless that was also part of the job so then it was
 seven then its a question did the world start to count on the first
 day or not until the job was finished at the end of the sixth or
 seventh thats hard to determine but at least you know what a
 day is

a day is something you can understand the sun comes up the
 sun goes down thats a day its a revolution of the earth on its axis
but what if you have to count years what do you mean by a year
 do you mean a certain number of days or do you mean the number
of times the seasons come around and in those days i guess they
 might have thought of the number of times the sun goes around the
 earth well the sun doesnt go around the earth and anyway the

sun doesnt go around the earth in an integral number of days　the
earth goes around the sun in 365 days five hours forty-eight minutes
and forty-six seconds

　　so maybe we should think about it in terms of months　but what
are months　months are figured by the number of days between one
full moon and the next　thats pretty good but it doesnt come out to
an integral number of days either　its actually twenty-nine and a half
days　and twelve months comes out to 354 days eight hours and
forty-eight minutes　which doesnt work out too well in relation to
the time it takes the sun to travel a cycle around the earth　thats not
so good

　　so youve got a problem　days dont work out neatly into years
days dont work out neatly into months　and the cycle of months
doesnt fit neatly into solar years　the jewish calendar is based on the
lunar year　and the roman calendar is based on the solar year　so its
not very easy to compute the year one with any certainty　and its no
easier thing to try to compute the year two thousand

　　i begin to think that finding the year two thousand is like painting
a wave white in the middle of the sea and saying　lets gather there and
celebrate　well go out to the right place　575 waves out into the
atlantic were going to make an indelible white patch and then were going
to take our lifeguard boats and go out there and find it　thats what
the year two thousand is like　its like a white patch in the middle of
the atlantic ocean

　　now since i start from this particular way of understanding time
and have a kind of disdain for what its about　sort of　even though
i would like to arrive earlier than eleanor　at least i try to get there
earlier than eleanor　but thats because i have some idea of what time
it is

though im not always sure about it because when i start
thinking about 1971
 well i have a picture a photograph my sister
in law and her husband lived at a place on central park west right over
the park and theres a photograph of me in a corduroy suit playing with
a kid of about three or four years old who was my son blaise hes
named blaise cendrars after the poet but in english hes blaze and
hes sort of standing there and im throwing a football to him a little
blue football the kind that kids play with and its a great shot
taken from sixteen floors up through a canopy of trees shedding
cascades of golden leaves and i can see this tiny kid with a sort of
dutch boy haircut in a little corduroy lumberjacket and hes either
throwing the ball to me or im throwing the ball to him and were
standing among mounds of golden leaves between the shedding trees
and a blue chainlink fence that separates us from a small playground
lined with bright little childrens swings its a gorgeous shot and
michael my sister in laws stepson is a gorgeous photographer its a
gorgeous photograph in its full fall central park color and from the
photograph i think i can remember how old blaise was because that
was the year i think i think it was 1971
 well maybe it wasnt it may not have been because looking at
it it looked like it might have been a cold day in central park blaise
was wearing the kind of corduroy lumberjacket with fur trim that kids
wear in late fall when its already cold and if that was the case then
it couldntve been the year of the jewish museum show which
happened during a very hot indian summer
 inside the jewish museum it was a hundred degrees and all the
computers were losing their minds somebody had forgotten that at
certain high temperatures computers lose their memory or they
simply had not realized quite how hot it was that september or

when they planned the show they had figured that since the show
was to be in the fall and fall in the northeast is usually cool there
would be no special need to cool the computers and then they forgot
all about cooling them but then came the indian summer and the
computers developed alzheimers

 that was one of the great events of the show the alzheimers
effect on the computers

 every artist i know who signed on to work
with computers carl fernbach flarsheim agnes denes they had
all agreed to be on computers i had had grave doubts when jack
suggested controlling my piece by computer because in those days
powerful computers were as big as a whole gallery space and while
there were some smaller ones that were in the show they were
nowhere as powerful as todays tiny personal computers and they
had heat sensitive memories and didnt come with their own cooling
systems but much of the computing in the show was done from
much larger computers addressed through telephone lines in some
faraway air conditioned laboratory and when jack asked me about
computers i thought to myself do i really want to be hooked up
to the bell system do i really trust the new york telephone system
and as it turned out my distrust of the telephone system was justified
because just at that time the telephone repairmen were terribly angry
at the phone company probably for very good reasons and were
sabotaging the phone lines they were going around tearing out
lines and then collecting overtime for repairing them and the city
was going crazy with so many of its lines out of service so the
computer pieces in the show were either undermined by memory
failure or by the telephone company though my piece was not one
of them

 but as i remember the september of the software show was a

very hot indian summer and we were all melting away so it seems
unlikely that this picture was taken at this particular time

 now of course its possible that this picture was taken in 1971 and
the jewish museum show was in 1970 that could be validated if i
went to the catalog providing that the catalog was right catalogs
are usually right about dates you know if you can agree on your
count from the birth of jesus to the present or from the beginning
of the world to the present but i dont have a catalog here and you
usually have to deal with time without a book in front of you
 though
you might have a watch
 i have a watch that tells me what date it is
but its not always right because i dont always correct it for months
of different length and theres still the question how could i find
1971 in my memory what would it be like

 how do you find a particular time in memory usually you
position it around some event that means something to you and
you have some kind of temporal event structure in mind this
happened before that and that happened after something else and
you have an image of some of these events intersecting with other
events and this gives you a set of loose coordinates a kind of grid
on which you can fix the idea of a particular time but its a shaky fix

 consider how you would do this you want to bring one
memorable event together with another so when elly and i came to
california for us that was a big event we were total new yorkers
you can tell by my accent unless youre a new yorker in which case
you think we dont have an accent i know nobody in california
believes that californians have accents but i hear it all the time the
california accent the los angeles the southern california accent its
so distinctive to me i can hardly imagine not hearing it in fact it

changes when you go north of santa barbara yet californians dont think they have an accent but they know i have one

now eleanor and i drove to california in a 1951 chrysler in the spring of 1968 with our new york accents and our one year old son i know my son was one year old a few days after we arrived in san diego because he was born on june 10 1967 and then i had to begin teaching at the university in the fall the university begins its year universities are funny our university begins its year on july first but we dont start classes till the end of september nobody else in the world begins their years july first but californias universities begin them july first the world seems to end every june thirtieth and begin july first if we can trust the calendar and i imagine i can trust the calendar and say somewhat confidently that blaise was one year old so you imagine these dates you imagine the confluence or congruence of dates but most of them most of them escape me so i couldnt remember precisely what else had happened in 1971 what happened first or second in 1971

what was going on in 1971 if you live by media you could say they were fighting the vietnam war but the vietnam war had been going on forever i was beginning to think that the vietnam war was one of the things we would live with forever it would never go away no matter what we would do it would continually be there and of course in the beginning i didnt understand why we were fighting the vietnam war i didnt understand it i was an innocent when i went to the university of california

and the university of california san diego was more or less administered by navy people retired navy people and after two years at the university of california i didnt understand any better why we were in the war but i did understand why we couldnt get out of it there was no way that these navy people could ever get out of

anything that they were already doing their mentality was such that once they started doing something they had once been ordered to do there was no way for them to stop doing it you could never show them that what they were doing was directly opposed to whatever they were supposed to want to accomplish that it was undermining the ground they were standing on it wouldnt help they didnt understand it whatever they started doing they would continue doing till they died or until they were pulled away from it by a direct order from whoever had set them to whatever they were doing and even then they would only withdraw with reluctance and distrust any report that suggested they should stop doing whatever they had been doing the reports would be considered inauthentic or wrong because they contradicted whatever they had been doing which had to be right because thats what they had always been doing

everything in the university went this way and i figured that these were the kind of guys running the war so clearly it would never end

but finally the war seemed to end it didnt end in a very decisive way it seemed to end very much like the way it started and could have ended years before but then it was over so you cant even really locate the end of the vietnam war as a place on your grid

i know some people remember american soldiers remember people suddenly leaving saigon and there is a video image of all those south vietnamese soldiers and civilians trying to get onto the american helicopters that were leaving but that was not the end of the war for the vietnamese people though it seemed to dwindle away after that at least for americans but i guess the trojan war wouldve been something like that

for the greeks if not for the trojans odysseus would be trying to tell the story of the trojan war and hes there in the land of the

phaeaceans trying to tell how it all ended and he remembers the
trojan horse and the sack of the city but thats not how it ended
for him

 though there was the departure which was maybe a little like
the departure from saigon

 and he says i guess we were in the third year
of the trojan war maybe it was the fourth or the tenth and that
was the time everybody got sick or that was the time everybody
wanted to go home

 and he says im trying to remember and he says no im getting
confused i remember i was on calypsos island where they kept
feeding me viagra i had nothing else to do but eat viagra and fuck my
brains out and we couldnt get away from that whole scene until they
took the pills away you know how it was

 but how did he know which year of the war it was if we were
trying to locate the beginning of the vietnam war we might locate it
by the election of a president but which president was it was it
the election or when he was nominated what year was it if you
thought it began with the violation of the geneva accords it was
eisenhower if you thought it was when it became a public issue it
was kennedy and if you thought of it when it became a large scale
american war it was johnson

 and anyway what time was it where
was i standing in what light somehow you have to try to localize
it and when i localize it

 i had an image we were talking about celebrating birthdays and
people wanted to know if i wanted a birthday party and i said i dont
know if i want a birthday party because birthdays are a little bit like
being in a falling elevator and celebrating at every floor you fall and
then i thought about this again and i realized id only thought about this

since i got to be thirty because when i was a real little guy i always thought of getting older as an ascension you know how you have a different image of getting older when youre a kid how you cant wait

i remember i was sitting on a stoop with about five other little kids and we mustve been somewhere between three and five all of us sitting out having a conference on a stoop in brooklyn and were trying to decide how old we want to be because nobodys content being three or four or five its a bad time you dont want to be between three and five first of all everybody else is too tall youre always looking up and you get a crick in your neck from it you cant play stickball yet with the older kids in the street you know its not a good time youre too dependent somebodys always got to take you across the street and thats a drag and you cant drink coffee or they wont let you i actually had an aunt who snuck me coffee and it was like being free for a minute

she was my favorite aunt i lived with her and my grandmother and three other aunts in this house with a covered porch and a stoop and thats what i remember thats where we were sitting having this conference on aging and one kid said oh id like to be thirteen that sounded like a real good powerful male age i think all the kids were boys but im not even sure of that and one said id like to be fifteen and everybody agreed that was good and one said eighteen and then somebody said twenty-one no we said thats too old it takes two words to say it

we knew twenty-one was over the hill so we already had this ballistic idea like the trajectory of a shell you went up for a while till you reached a certain point and then you came down because even then we knew that whatever goes up also comes down and we had some sense of the failing of our powers at twenty-two and we would no longer be the same happy cute kids at the age of twenty-two

thats the view we had then and ive had several different views of
this since then

sometimes ive seen the movement of time as something like a
carousel

i was walking in balboa park in san diego san diego has a
beautiful park called balboa park its not as grand or great as central
park but its a very lovely park a lush park botanically we were
there i forget for what reason and we were walking by the prado just a
couple weeks ago and we were walking in the area that leads to these
grandiose stucco turn of the century buildings that they call the prado
because they want to evoke a kind of spanish grandeur and all these
buildings are decorated with stucco gingerbread and theyre really
very charming and we were walking by the outskirts of the prado
where there is this great carousel its a very old carousel the kind
with dragons and griffons and palfreys that keep coming around and
going up and down and these are the fanciful animals that children
know and love and we remembered going there many years before
when our kid was about the age he seemed in the photograph where we
were playing football in central park and i kind of think of the
seasons as going around like a carousel

now you may think thats not a good image because if you watch
carefully as it all goes around you see that the seasons are not always
the same but the carousel is not always the same either because
you cant always pay perfect attention to it and you miss a black horse

you know its like rilkes poem about the carousel he seems to
want to pay constant attention but what he notices is intermittent
every now and then he spots a white elephant going by now its
probably the same elephant but hes not sure about that and he wants
to let you know that so he tells you several times every now and
then theres a white elephant but whos sure its the same elephant

now when spring comes im not always sure its spring not the
spring i recognize nowadays i dont even know when its spring
sometimes i think this is a great spring a great moment but its a little
displaced you know how when we were kids we might have thought
this is very inappropriate for may its really more of an april a
belated april but kids know everything at least we all knew
everything about new york we knew when forsythia should come
out when the pussy willows should be out but what happened if
they came out wrong this year i was in new york just a few weeks
ago when it should barely have been spring it was april it was
eighty-nine degrees what kind of spring was that summer showed
up and went away the merry go round went out of synch somehow
we had a merry go round and it wasnt rolling right you know you
keep watching yourself on the merry go round now you can even
see time going by as a merry go round if you watch it from off the
merry go round

but i can also see myself on the merry go round watching the
world go round and then the world comes around and around and
you see it again or every now and then which is another way
but you could see it that way and you see how you could get to ride
longer there used to be a way you could get to ride again if you
could catch a gold ring that was the prize you could get to ride
longer if you could reach the gold ring that was on a beam just
outside the merry go round but if you were too little you couldnt do
it somebody would have to hold you and you would try but you
couldnt reach the gold ring but the idea was that if you got the gold
ring you got an extra ride i dont remember if thats really true i
dont remember if it ever really happened it sounds a little like the
mythical good humor stick

when i was a kid good humor used to sell these ice cream pops

chocolate covered ice cream on a stick and there was a rumor that
there was a magical stick that would give you a prize nobody that i
knew had ever won this prize or seen this differently shaped good
humor stick that when you ate the ice cream pop you saw something
 printed on it or it looked like a propeller or was somehow different
and got you some fabulous prize though nobody knew what that was
 well the gold carousel ring was a little like that i had seen the
rings i dont think they were gold and i dont know if they got you
another ride but if you didnt get the ring which was what always
happened you didnt get another ride and you had to get off the
merry go round so you can measure time by when you have to get
off the merry go round and the sense of it comes from seeing it
happen again
 not for the first time but seeing it again and again and
recognizing it now this is the time of the year when we see forsythia
or when the minute flowers on the maple trees suddenly show up
for a moment in central park
 its a great moment where the trees that have been bare all
winter bare in the fall and bare in the winter and then before they
turn into the grand green leafage there is this moment when they have
a feathery look that makes you think your eyes are going bad but its
just a moment and very soon theres this green dust on the ground
its just a moment but a great moment the moment of spring and i
always used to look for it
 but you dont always get to see it sometimes the rains would
carry the maple flowers away before you got to see them and there
might be no landmarks for the spring
 now i have another way of looking for the cycle that would make
it possible to figure the time though maybe its even more bizarre
suppose you think of yourself on an escalator youre on an escalator

and say youre on an escalator going up youre growing youve got a
career youre going up the escalator and the career is carrying you
almost without effort you know this is not really true but it feels
that way it feels good

youre doing well you know youre having shows youre getting
published youre on an escalator and its going up but you know at
some point youre going to be catapulted off the escalator so how do
you stay on the escalator the biggest artists problem is how do you
stay on the upper half of the escalator without reaching without
getting pushed off

so what you do is run backwards youre busy running backwards
its very busy running backwards as you keep running in order not to
get to the top of the escalator and not to get off at the bottom and start
over you know youre not trying to get down to the bottom youre
trying to stay in the upper quarter of the escalator desperately the
whole art scene my sense of the whole art scene is like this i watch
people doing this all the time theyre busy jogging in the wrong
direction on the escalator but theyre also looking for something
while theyre jogging something familiar

because the longer theyre on the escalator the more strange faces
begin to appear on it people are coming up and passing them people
they dont recognize anymore their contemporaries are getting
bumped off the escalator and theyre still on the escalator and
obviously they think its a much worse art world because they cant
recognize all of the people in it

what do you mean all these new people on the escalator are
making me very nervous i dont recognize them and since you cant
recognize the people you keep looking at the escalator to see if the
escalator has some familiar step a step with a deformation in it you
look for a place where the escalator has something peculiar like gum

stuck into it because you know the escalator is a continuing series
of steps that cycles around and around and around and the same
step that stood up once to lift you up goes down and flattens out and
then it comes around and lifts you up again so you want to find the
place on the escalator that you remember and its very hard to
recognize

have you ever tried to recognize a step on an escalator its
very difficult to recognize the step you last stood on on the escalator
its very hard i know how hard it is and it happens to everybody this
need to find the right step your step the step that you recognize on
the escalator and this need came home to me not with my own life
but in the life of my father in law

my father in law was a hungarian poet painter his name was
moor peter that was a nom de plume his real name was barna
joszef but he took the name moor like the moor of venice or
thomas moore the irish poet took this as his pen name in budapest
and if you take that name in budapest nobodys called moor there
where he had a grand early career or a very quick early career he
was a poetic wunderkind he was adopted as a young writer and
immediately became accepted in this great hungarian magazine
published by the great hungarian poet ady who accepted three stories
by young moor peter in this great magazine called *west* in hungarian
nyugat because it was the westward looking magazine but the
trouble was the first story got published and peter became
instantly famous for a minute then came the revolution and the
counter revolution and *nyugat* got shut down never having had a
chance to publish the other two stories and peter had to flee the
country and go to vienna where he got some work in alexander korda
films in those days they were silent films so he didnt have to speak
german because his german was very poor but then he came to the

united states and here in the united states he was a man who spoke
very poor english and was nevertheless a hungarian poet who became a
painter and a poet

that is he continued to write hungarian poems which
were broadcast over hungarian radio anti fascist hungarian radio in
new york and he had a kind of circle of hungarian friends and he
was constantly trying to find the step on that escalator that had lifted
him up into the center of the budapest hungarian publishing world
from which he had been cast out cast off the escalator by revolution
counter revolution and the turns of the world that he lived in and he
lived a very interesting life he became a very beautiful painter
but he always thought of himself as a hungarian poet we have his
paintings his paintings are wonderful theyve been exhibited and
all that

and in some way he may even have been a much more original
painter than a poet but that doesnt matter because he was so deeply
embedded in the hungarian language by his love of that language
that he kept looking and looking and looking to find some way back
he even translated some contemporary hungarian poetry into his then
reasonably good functional english but hungary had gone to a
different place he was an old leftist poet from a country that was
suffering from stalinist lunacies that could no longer find a way to
appreciate him he was gone the way solzhenitsyn was gone from
russia he was a displaced hungarian poet living in la jolla
so one day hes on the tennis court at the age of ninety-three
showing a beautiful young woman how to put away a serve he shows
her how to put away the serve he trips and falls and breaks his hip
breaks his hip and goes to the hospital and in the course of the
treatment they give him heparin to keep his blood from clotting
and unfortunately that makes him worse he has a stroke hes dying

at ninety-three when someone dies you usually expect it but
he was in good shape and we werent expecting it we werent ready
 for him to be dying i was used to his arguing with me about goethe
and all of german and hungarian literature he never failed to explain
their excellences which were sometimes hard for me to take and we
used to argue he would explain to me why kurt vonnegut was too
 smart to be great or why charles olson was too smart to be great he
was a wonderful wonderful old guy he was terrific and he was dying
 and we were beside him and we tried to talk with him but his
english which was never very good was now much worse now that
he was dying and he must have had a stroke though we didnt
realize it at the time so it was much harder than usual to communicate
with him and he was very impatient with us for not understanding
him he kept trying to tell us something that we didnt understand
 as we tried to talk to him about his life and console him by reminding
him of what he had accomplished as an artist and writer but he kept
waving us away shaking his head and repeating one word over and
 over again

 i dont know much hungarian i know a little but i dont know
much he had taught me one sentence that i remember very brilliantly
 it was the first sentence he learned to read in school which goes "o
legyelsho magyar ember o kirai" which means "the first man in
hungary is the king"

 which tells you what kind of country he grew up in and when
 but my pitiful stock of hungarian words didnt include the one word
he kept saying over and over as a kind of denial of what we were trying
to tell him as we tried to console him about the meaning of his life

 zaha he said zaha shaking his head and repeating it over and over
zaha zaha to anything we had to say it didnt mean anything to me
and of course there was plenty of hungarian i didnt know so as he lay

there dying i didnt have any idea what he meant later i tried to look
it up in my hungarian dictionary and i couldnt find anything remotely
like it

anything but one day im talking to a friend a marvelous
virtuoso hungarian violinist named janos negyesy and i tell him
about the word and he thinks a moment hes a musician and he says
zaha its an inversion

thats *haza* it means homeland

so it was as if someone speaking english would say to me
dnalemoh dnalemoh for homeland so it was homeland he was
trying to say only i couldnt figure it out he was somehow trying
to find the step his step on the escalator that particular step that
had lifted him up and had somehow disappeared and i dont know if
it was the budapest world that had welcomed him or the little town
of keckemet where he had been born

but he was thinking of his homeland and of course budapest is
no longer his budapest and keckemet is no longer the little town
where his father painted the interiors of churches but he was
looking for this one place that he was sure never ever to find again

sanda agalidi asked me to come up to talk at cal arts where she was
conducting a seminar on the experience of time sanda is an old friend
an idiosyncratic art historian and critic who many years ago had
been a graduate student of ours at ucsd to which she brought a great
intelligence a deep european education a masters degree from the
university of bucharest barely a word or two of english and the
haunted look of an iron curtain émigré

when she left us with an mfa to go on to a doctorate at ucla which
she completed with a brilliant thesis on *neue sachlichkeit* painting she
spoke a fluent romanian english that she perfected with years of teaching
at the california institute of the arts in valencia though the luminous
california sunlight had done little to brighten her eastern european soul
so i knew that any seminar she was teaching would be eccentric and
interesting and i was also interested in going over once again what
still seems to me the inexhaustible peculiarities of the experience of time

time

on my

hands

of course everybody is always dealing with time in some way or
another so was i this morning
in fact the whole idea of coming and talking at ten in the morning
was already committed to an engagement with time since i was

coming from san diego to talk at ten in the morning and ten in the
morning is quite early to make a trip up to mcbean parkway when
youre coming from san diego it used to be faster to come to mcbean
parkway and then it was slower to get to mcbean parkway and
then it got faster again

at different times there were different speed limits when i first
came to california in 1968 there was a seventy mile an hour speed limit
before they clamped it down and the trip was so quick because there
was nothing here back in 1968 cal arts wasnt here this was a place
where white tailed deer ranged when they could find water coyotes
of course and other small beasts valencia wasnt here either back in
1968 i think there were a couple of ranches back then and i had
come to san diego for the odd experience of teaching which i had
never desired or intended to do i was invited to come out and be the
director of the art gallery of the university of california at san diego
and teach a few courses in spite of the fact that my graduate work was
in linguistics

but i was a writer and i wrote art criticism and i was a poet and
they told me thats what they really need you put some slides up
people will look at them and sometimes youll talk about them and
theyll wonder why youre talking about them but after a while theyll
get used to the idea that even if they dont know why youre talking
about them itll be all right this was the version given to me by paul
brach the man who founded the art department up here but that
was after he founded the art department down there and once again
were talking about time

and its curious how talking about past time involves the memory
of time its one thing to experience time and another thing to
experience past time which is already over and to imagine future
time which isnt there yet or sometimes to put yourself in past

time and imagine a future time that happens to be over for which
they have tenses in some languages that can drive you crazy a
future perfect where you imagine a future thats already over but
you put yourself in a past in order to imagine it

when i started out this morning i knew that saying ten oclock
ten oclock was rather early the earliness didnt bother me because
i wake up around six or so anyway the sun comes in our windows
our bedroom faces the east and by the time the sun comes in this time
of year its a function of the time of year and this time of year the
sun comes in very early im up by six and that wasnt a problem

the question was to figure out how to arrive at something in the
nature of ten oclock ten oclock is a very specific moment in the
division of the day an arbitrary mechanical or astronomical
division of the day it stands in a particular geometrical relation to
the position of the sun when it stands directly overhead which is at
noon or at an azimuth of zero degrees so at ten oclock its two hours
before the sun stands directly overhead which is sixty degrees
below the zenith or an azimuth of sixty degrees all other things
being equal

but theyre not equal because were on daylight saving time so
that ten oclock is really nine oclock and the sun would stand at an
azimuth of ninety degrees or at an angle of ninety degrees below the
zenith more or less depending on where were located within a
given time zone

but the real question was how precisely i was to respond to ten
oclock would that be the same as five to ten or ten-fifteen a quarter
of ten or ten-thirty actually i arranged to meet sanda outside the
main building at a quarter of ten so i had a target of some sort but
while the fractioning of the hour changes the scale of exactitude
somewhat it doesnt change the nature of the question it simply

raises a similar question about the divisions of the hour was
a quarter of ten exactly fifteen minutes before ten or was it
roughly how roughly

 when i think of roughly im always reminded that sometime
around the fourteenth century or maybe it was the fifteenth century
a great council was convened by the emperor sigismund to resolve the
differences among the feuding parts of the catholic church and to
determine among other things which one of the three claimants to
being pope was the real pope the council was to meet on the shores
of lake constance and the meeting was set for the middle of april
which was already spring and as it probably promised mild weather
and early flowers must have seemed like a good time to resolve
differences so the great dignitaries of the eastern and western
churches set out crossing land and sea and started to arrive and
some arrived by april tenth and some arrived by the thirteenth and
some by the sixteenth and the eighteenth

 and when they got there they set up their pavilions and settled
into what must have been a festive scene of ceremonies and games
surrounded by markets with rug merchants and horse dealers with
musicians and dancers and jugglers and acrobats and tightrope dancers
and gamblers and pawnbrokers while they waited for the latecomers
among whom was cosimo di medici who didnt arrive in april or in
may but he was a great merchant prince and banker so they
waited through april and may till he finally arrived in late june
when they started their deliberations

 and by november they resolved whatever differences they could
resolve and then went home

 so the question for me was how close to medici time did i have
in mind for my ten oclock appointment with sanda here in valencia
outside the main building of cal arts i thought we intended to be a

bit more precise than cosimo because in a school the day is divided into
periods of time when i was in high school they used to ring bells to
let you know a period was over or a period was about to begin high
schools and elementary schools were defined by bells youd be
working at some problem or other and then brrrnng and everybody
would suddenly rise up in the midst of whatever they were doing and
rush madly out the door into a crowded hallway to get to another
room where they would sit down and start doing something entirely
different for another short period of time that would then be
interrupted by another bell and these bells would go off in a way
that was related to the large wood framed clocks they used to have on
the wall and they would always go off something like ten minutes
before the hour and that was on the theory that the hour was a
beautiful moment nine oclock ten oclock but they used to ring
the bells ten minutes before the hour on the principle that if they let
everybody know ten minutes before the hour they would all get to
their new place precisely on the hour of course that never happened
anyway the bell would ring and the kids would scramble to gather
up their things and rush into the hallway where they would wander
around gossip with their friends go to the bathroom go for a smoke
and do whatever they did and arrive at their new place whenever they
were through though this didnt happen with everybody some
kids got there earlier some kids wandered in later the way it usually
happens in life

 so i had to figure out how was i going to get here how long does
it take to come up the freeway on I-5 before it becomes the 405 and
wanders in a sedate manner somewhat to the west before it rejoins 5
somewhere north of l.a. on the rest of the way to mcbean parkway i
figured its gotten very fast to get to l.a. thats about 110 miles and
certain times of the day you can make it to l.a. in an hour and a half

though its uncertain what certain times of the day that time will be

thats the most uncertain thing about it when will you be able to

travel a full seventy-five miles an hour to get here so i figured it

would be wise for me to be on the road by seven in the morning

and that if i came too early if it turned out there was no traffic on

the road at all i could stop in santa monica get a caffe latte and

continue the trip arriving in plenty of time to meet sanda if it turned

out that the road wasnt empty three hours still seemed to me like a

marvelous amount of time

so i get on the road and im driving along speeding past the beach

towns of san diego past del mar solana beach cardiff encinitas

leucadia carlsbad and oceanside and theres traffic on the road but

were all speeding along on this clear day from which the sun has

burned off the morning overcast and then in a totally bizarre manner

theres suddenly a traffic jam this was not unpredictable it happens

nearly all the time but there was no particular reason for it cars

are suddenly stopping and then proceeding at a crawl that stretches a

good half mile ahead

yet theres no accident i can see there are no feeder roads

suddenlyemptying into I-5 theres no visible reason cars are just

stopping and theres a traffic jam that then in an equally illogical way

just opens up

and were speeding again till the next illogical traffic jam and

were proceeding in this way racing from traffic jam to traffic jam all

the way to san juan capistrano where were approaching the toll road

that for two bucks and a quarter lets you race through the back

country behind irvine almost to huntington beach and i figure for

two bucks and a quarter its worth it so i dont leave sanda out there for

half an hour because i expect sanda to be standing out there wilting in

the hot sun waiting hopefully for me to arrive and wondering
whether ill be coming an hour late but an hour late seems excessive
 so i take the toll road i get on the toll road and its the first time
ive ever seen the toll road have a traffic jam this was really startling
and i reflected this has really got to do with the time of day this is
the time of day when all these people go to work all these people
work in software companies where people start working at ten oclock
thats why theyre on the road at this time ten oclock is a bad time to
have to arrive in an area where all the people work in the tech industry
if everybody just worked at blue collar jobs as truckers or construction
guys theyd get up at five and out on the road by six in the morning
if they worked in meat packing houses theyd be up early if they were
factory workers theyd be there before eight software workers walk
in at ten oclock i realized this was my mistake i should have
figured a way around this
 of course i could have stayed in los angeles the night before
except i had things to do in san diego san diego is 130 miles maybe
closer to 140 miles from here los angeles is only thirty miles south of
here or something like that so i should have stayed there but im
in the middle of something thats taking a lot of my time im in the
middle of a long email dialogue with a friend of mine the poet
charles bernstein email is nice because it doesnt take any time to
send but to write it when youre writing seriously

 you see ive never
learned how to deal with email the way everybody says email is used
i write email the way i write letters some people dont some people
dont put english sentences down there that would be all right if they
wrote french sentences or german sentences
 french sentences would be fine when sanda first came to

california she didnt speak english and i didnt speak romanian so
we communicated in french sanda will remember that when she
first came to the university of california at san diego there were only
two of us in the art department who could speak to her subsequently
shes become so fluent she sounds like a native californian and
teaching up here shes developed a perfect valley accent

but since it would have been very inconvenient for me to come
up to los angeles the day before i had to deal with the timing of the
morning traffic between san diego and valencia and here i was on
the toll road trying to deal with the opening up and closing up of traffic
which gives you a very different sense a kind of accordionlike
expanding and contracting sense of time

now i wasnt feeling very pressured by this because having
three hours i was reasonably sure id get here within ten minutes either
way of our appointed time unless there was some unforeseen
disaster on the roadway some dreadful accident that overturned a
trailer truck that spilled hundreds of thousands of marbles on the
roadway or a frantic gun battle between the police and a desperate
band of bank robbers holding them off with ak-47s

i once saw
something like this on the highway it was about twenty years ago
and i was giving a talk at cal arts i seem to do this intermittently
i was giving a talk at cal arts and i was on the way home i had the
radio on and i was listening to one of those all day news stations i
was just south of northridge and a reporter broke in to the ritual of
the regular broadcast to announce a gun battle going on in south los
angeles where the police had somehow caught up with the scruffy
group that had labeled itself the symbionese liberation army the
group that had robbed a couple of banks and kidnapped patty hearst
who was now a full fledged member of their so called army the

army was apparently hiding out in a safe house in south l.a. when
the police caught up with them and they were exchanging rifle fire to
the great excitement of the news staff which was following it like a
battle in vietnam "theres some fire from the house the police on
the south side are returning fire the roof seems to be burning
theres a native on the porch side running for cover . . . " and suddenly
i was in a traffic jam suddenly the whole 405 came to a stop north
of manchester because everybody else had their car radios on and
realized they could watch the gun battle they were listening to from
the highway so i sat there too listening and watching from my
stationary car on the 405 till the action apparently subsided and all
the drivers decided to continue on home later i heard the police
who had surrounded the building were firing into it from two sides
so that every time the police on one side fired into the building they
received answering fire from the other and they kept this up for
some time before they realized they were exchanging fire with each
other while the symbionese liberation army had either slipped away
or never been in the building at all

so coming here with the intention of arriving in time to meet
sanda i was reminded of all the other times id come up to talk at cal arts
in fact i taught a course here once i got conned into teaching a
course here by john baldessari and paul brach paul was the person
who founded the art department up here i used to come up here
once a week and it was an interesting experience because after a while
the drive got so automatic that it disappeared and i never knew
what happened to it in those days i lived in solana beach id come
out of my house get in the car turn the key in the ignition and before
i knew it id arrive in front of this insane building in which the rest
of the day disappeared i never understood this building which seems
to have been designed to withstand all climatic events a hermetic

container aimed at being a future time capsule you lose all sense
of weather in this building there could be a raging storm outside
 and you wouldnt have a clue

 so i would get out of my car go down into
this building where id have a very pleasant talk with my class all the
 time wondering what the weather would be like when i came out
then id come out get into my car and wake up in solana beach so
 that was a time that disappeared

 today it didnt disappear it was interesting every moment
 along the way i could register how the time was unfolding and it
unfolded very unevenly there were periods during which it unfolded
very slowly and i had a nearly physical feeling of its unfolding it
was not a feeling of the environment i was passing through or my
 physical situation in the car it was a sensuous feeling as if somehow
a surface in my physical being was slowly unfolding and then
 something happens and suddenly its over and everything is going
very quickly even though youre not moving

 youre in a traffic jam and youre very aware of the moments of
the traffic jam one car is driving very peculiarly moving from one
 lane to another you figure this guy is setting himself up for some
kind of accident the trouble is you want to keep away from him
 because hes going to create an accident three cars back and this black
cherokee is weaving back and forth back and forth and cutting in front
 of other cars like hes desperate to gain three car lengths which seems
odd because three car lengths up youre not much better off than you
were before so i started speculating on what urgency he must have
 had i kept wondering where was he going

 i knew he wasnt on his
way to meet sanda i thought hes got some kind of rendezvous he
 told his wife some story and hes on his way to meet a girlfriend and

hes got to get there on time because shes going to think he stood her
up if he arrives late shes going to leave the motel and go somewhere
else shes probably going to go to the flamingo lounge and pick up
somebody else and hes very distressed because she has a very bad
temper and shell take off with somebody else and leave him stranded
there and hes gone to all this trouble deceiving his wife telling her
he was meeting his accountant to handle a special tax problem and
making a great show of taking this briefcase filled with papers and
really this is all so he can meet his girlfriend and im beginning to
feel very sorry for him but then i wonder why doesnt he call her
doesnt he have a cell phone like everyone else driving today you
realize the cell phone has transformed the car into a communication
center

the car is now a communication center people are on the phone
doing etrading driving with their left hand but doing etrading while
switching lanes is very interesting especially if theres a great change
in the price of your stock or youre trying to place an order a limit
order committing you to buying at this price but not a higher price or
to selling at this price but not a lower price but youre having trouble
getting through to your broker or your phone contact is breaking up
because you have a bad satellite connection the way most people
have between oceanside and san clemente

but up here theres no telling it may be because of the heavy
satellite traffic everyone is on his cell phone trying to reach his
broker from the same place on the toll road north of san juan capistrano
and south of huntington beach orange county may be the heavy
etrade place so this guy if he had a cellular phone may have had
trouble reaching his girlfriend or she may not have had her cell
phone on though i realize these people always have their cell phone
on theyve got it plugged into their cigarette lighter and theyve

always got extra battery packs my cell phone always seems to go
dead i dont know what it is i always have my cell phone off its
resting in my backpack till i have to make one call i take it out and
turn it on and it has no energy left it seems to be very fatigued
maybe its because i dont do much with it and it feels very neglected
the people who use cell phones all the time they always seem to
have them working nevertheless the satellite doesnt always transmit
when you want it to particularly when youre in certain places far
from home

because then youre roaming and you have to pay higher
charges and lots of people are very sensitive to this and unwilling to
pay these roaming charges that cost a few cents more even though
theyre calling their broker and could lose thousands of dollars if they
cant get through but theyre worried about a dollar or two toll thats
charged by another group that puts your calls through to the satellite
in this area and thats one of the real problems of our moment

and so im thinking about this while im coming up and all this is
going on and at the same time im reflecting on all the other times
ive come up here before and im remembering how this place before
it became a solid place was an imaginary place cal arts was an
imagination in the minds of the disneys and in the minds of the people
they approached to realize it

the disneys apparently owned or acquired a great deal of open
ranch land in this area north of los angeles where they imagined
starting some great art school either because they felt a need for a
greatly expanded and updated professional school like chouinard that
could provide them with an unending supply of up to date talented
animators and filmmakers or because they knew that nothing raises
real estate values faster than the creation of a prestigious school so

with either or both of these considerations in mind they got themselves

a president who seemed like the kind of person who could put together
the kind of prestigious art school they wanted and the person they
picked was bob corrigan a very personable theater historian with a
strong attachment to the contemporary theater avant garde and the
first thing corrigan did was go out and hire a group of deans to turn
the imagination of an up to date school of the arts into a concrete reality
 to head the visual arts corrigan went to paul brach whod started
the art department down in san diego paul was a refined optical
painter with a long teaching record and could have fit into any kind of
sixties art school but he brought in allan kaprow as his associate
dean and that immediately raised the experimental stakes corrigan
recruited his friend herb blau to head the theater school blau was
a modernist theater director from san francisco whod briefly taken
over the new theater at lincoln center where he immediately staged a
disastrous production of dantons death and promptly left either
because he was too experimental for the new york theater establishment
or not experimental enough to override their predictable objections
 corrigan got mel powell a midstream modernist with a long career
that moved him from his jazz beginnings to a neoclassical style in the
fifties and to a postwebern style and experiments with electronics in
the sixties to take on the music school and he got bella lewitzky a
founding figure of modern dance in los angeles to take on the dance
school
 somewhat weirdly or maybe not so weirdly considering the
disneys he got sandy mackendrick a skillful director of hollywood
farces to run the film program there was also a design school run by
an ex-disney animator with a background in bauhaus and a school of
critical studies that was to be run by a hip sociologist from brandeis
named maurice stein
 so the deans were a mixed group and the differences between

them were significant because they all had different imaginations of what it would mean to have an up to date school in their separate arts but these differences were as nothing compared to the differences between the deans and the disneys because the deans somehow collectively arrived at a vision of the school as a kind of updated version of black mountain college

thinking about this now it seems completely implausible black mountain was a small and nearly penniless experimental college formed in the deep depression of the 1930s aiming at a progressive liberal education in which a small number of students would try to work out their individual identities in community living with a tiny faculty as they meandered through a sparse curriculum in the foothills of rural north carolina while hitler was consolidating his grip on germany it was never a professional school or even an art school even though its founder brought in josef and anni albers two bauhaus refugees toward the very beginning probably out of a deweylike idea that art making as a form of concrete doing should occupy a central role in a real education while the california institute of the arts was founded as a consolidation and expansion of an art school and a music conservatory with the vast wealth of the disneys just thirty miles north of glamorous affluent los angeles in rich 1970 america

but by the end of the sixties when they were planning the new school black mountain college which had been disintegrating almost since it started in 1933 till it finally dissolved in 1956 had developed a legendary reputation everybody in the art world knew it as the experimental school where albers had taught where rauschenberg and kenneth noland had been students where merce cunningham had staged some of his first ensemble dances where bucky fuller had put up his first dome and cage had staged the first happening and even if most of these famous figures were only there

briefly or just visitors at its summer institutes the school was
connected in everyones mind with the sort of experimentalism that
questioned authority of every kind including its own and this was a
time when students in america and around the world were beginning
to question seriously authority of all kinds especially the kind that
had led them into the disastrous and ongoing war in vietnam so
maybe it was not such a surprise for maurice stein to suggest and for
the other deans to accept the idea of hiring herbert marcuse as a
professor in the school of critical studies though it seemed pretty
surprising to me back then when it came up at a meeting of the deans
they were holding down in san diego maybe because marcuse was
teaching at ucsd or because paul brach was still teaching there and
he was helping to plan the new school

 which is probably how i got taken along to this meeting that
was an informal dinner at a mexican restaurant in la jolla where i
first heard steins idea of recruiting marcuse and i thought it was pretty
funny

 but to realize how funny it was you first have to remember that
ronald reagan was governor of california nixon was in the white
house and h.r. haldeman nixons chief of staff was on the board of
trustees that the disneys had set up for cal arts while marcuse was
the darling of the new left or of its youth movement in spite of the
fact that he was really an elderly german intellectual whose radically
revisionist marxian ideas of the liberational possibilities of the sexual
revolution were invariably expressed in the pedantic prose of the
hegelian dialectic so he must have looked to the southern california
right wing like a combination of bakunin and havelock ellis besides
which he had an absolutely negative relation to just about all
contemporary art

 but maurice stein was a very hip sociologist he was so hip you

could hardly be hipper so i suppose he wanted marcuse not only
because he was a respected philosopher and a distinguished member of
the frankfurt school but also because he was spectacular in the way
he attracted students to political activism and maury was in some
ways what in yiddish they call a *kochleffel* which translates a little
lamely into "ladle" but a ladle is something thats always stirring
the pot and maury liked to stir the pot

as i remember it he said he was thinking of getting herbert
and i objected you know theres no place where he can go and walk
along a street herbert has to have a place where he can stroll down
the street with his hands behind his back and peer into shop windows
can you imagine him doing that in valencia if he doesnt have a street
to walk along he could become deranged he wont feel like hes in any
place at all coyotes and deer will amaze him spotted owls will puzzle
him there will be nobody for him to gossip with and no place for him
to go in for a *kaffee mit schlag*

but maury dismissed all this he knew that it would be fine to
have marcuse here but i said hes such a sentimentalist about art
he thinks all real art is about ideal beauty he thinks the works of
surrealism are canova nudes theyre pure beauty because theyre the
objects of an unaccommodated desire generated out of the unconscious
which is not acculturated and denies the crass materialism of bourgeois
culture and the commodified pleasures it distributes as kitsch the art
school wont know what to make of him he may inspire students to
get involved with politics but every time he thinks about art hes going
to think about max ernst and thats all very well but max ernst is
dead maury said oh well lots of people are dead its all right dead
people can act anyway look at marx

i wasnt sure that max ernst could act very significantly at this
point in time but all this was taking place in the vacuum that

existed before cal arts became real down at our school at ucsd
marcuse had been teaching for several years and we had plenty of
time to observe him he was a kind of paternalistic old gentleman
 with a train of disciples consisting mainly of literature and philosophy
students and faculty who trailed after him like a bunch of ducklings
 following a mother duck mostly to demonstrations against military
recruitment or the war i dont remember ever seeing him at art
exhibitions though angela davis who was his most beautiful and chic
disciple invariably came to all of them but the one time i do remember
 he got involved with contemporary art was on the occasion of an
exhibition by martha rosler who was a graduate student of ours back
 then she was putting up her first year review show and as a new
yorker who had only been in san diego for a year or two was fascinated
 with the southern california phenomenon of garage sales weird
occasions in which people who moved on an average of once every
 five years regularly emptied onto their front lawns all the objects
theyd once bought or inherited or traded for and no longer found
 useful or necessary or beautiful or simply considered conveniently
replaceable so it was a common sight to drive through a town like
solana beach or encinitas on any day and pass three or four little
houses whose well watered green lawns had turned into thrift shops
 displaying plaster saints gold leaf framed mirrors ladies dresses
childrens toys kitchen tables small television sets phonographs and
 vinyl records makeup cases power tools and lingerie and martha as
someone whod frequented a few of these sales when shed simply
 needed a few cheap things for the house because she was a graduate
student and didnt have much money had become fascinated with
 them and began to study this emptying out and evaluation of ones
past as an exercise in autobiography
 so for her first year review she turned the student gallery into a

garage sale and as a young conceptual artist because the art world
was into systems then she schematized the objects somewhat
arbitrarily and as i remember somewhat ironically along freudian
lines so that things like underwear were assigned to the id toasters
and mixmasters to the ego and books to the superego im not really
sure of the exact arrangement but it was something like this and of
course because in a truly contemporary way she wanted her show to
be a garage sale not merely a representation of a garage sale she put
little price tags on the objects and actually sold them thats where
the show collided with marcuse

im not sure he ever really saw the show but many of his
students knew martha she also had leftist philosophical interests
and many of them saw the show and one of them who is now a
successful literary agent for commercial novels was so outraged by
the show that she wrote a very long and bitter attack on it in the
school newspaper

martha who was very sensitive was very hurt by the review
and brought a copy of the *triton times* to show me because i was a
friend but also one of her advisers i read the article and it was the
standard marcuse line how marthas garage sale was a flagrant
example of contemporary art being co-opted by the commodity values
of the surrounding bourgeois culture where the responsibility of art
was to stand back from all this and defend the human powers of the
imagination by the beauty of its form and so on

what should i do she asked martha i said this is not so terrible
its an opportunity you have to write a response and you write a
lot better than sandy dont defend yourself and dont attack her
this is a marcuse position go out and kill him take his theory of
art apart he thinks of artworks as canova nudes he thinks by
putting them up on a plinth they attack bourgeois culture by their

refusal of any relation to it this is frankfurt school nonsense
adorno made even more ridiculous by the freudian twist marcuse gives
it write an essay for the paper and go out and kill him

so martha wrote an essay for the *triton times* she took my
advice and it was pretty devastating the result was that the art
department received a message from the philosophy department an
invitation to discuss the role of esthetics in counter-cultural thinking
in other words who was more left?

the meeting took place one night in the philosophy departments
seminar room a fairly narrow space with a long table the philosophy
and literature folk on one side of the table and the visual arts people
on the other marcuse sat near the head of the table and on the
same side of the table were reinhardt lettau the german short story
writer marcuses wife and arthur danto who was a visiting lecturer
that year and there may have been one or two others im not sure of
on our side of the table elly sat directly across from marcuse i was
next to her and next to me was allan sekula and next to him fred
lonidier martha was too sensitive to come

in the beginning we were all very tentative and polite trying to
see if we could agree on the terms because if we couldnt agree even
loosely on what we thought art was it would be pointless to argue
about it but it may have gone on a bit long because marcuse became
somewhat impatient with it he pounded the table with his fist
"nonsense!" he said in his heavily accented english "we all know
what art is"

"so what is it" i asked

"art is the imaginative transformation of reality"

"so is advertising so what?"

that was the end of the amenities and it was open warfare for a
while but elly introduced a conciliatory tone

"you know" she said to marcuse "i think i agree with you
about beauty and i tried for a kind of ideal beauty in my most
recent work its a sculpture and i used the traditional method of the
ancient greek sculptors who worked gradually all around the figure
refining and refining"

marcuse was intrigued "but" elly said "im a poor conceptual
artist and i cant afford parian marble so i used my body i went on
a diet for thirty-six days and every day i photographed myself nude
front and back and both sides till i reached the perfect state for my
own body it was the best i could do as michelangelo said not
even the greatest artist can get anything out of the stone thats not
already in the marble"

marcuse exploded "young woman you are a sophist!"

thats why i thought it was a funny idea to hire marcuse to teach
in an art school but maury made the offer and predictably it
drove the trustees wild which may have been what stein wanted
but marcuse who was rather chivalrous about it declined it in the
interests of the schools survival so marcuse never came up to cal arts
to teach and the disneys didnt shut the school down though they
very nearly did about a year later when the school got started in
temporary quarters on the grounds of an old catholic school in burbank
because the art students they recruited had their own sense of what
the school should be like which may have been a cross between black
mountain and a commune so in the spirit of the sixties which were
by no means over in 1971 in the interests of freedom and
wholesomeness and ordinary teenage sexiness they decided on nude
swimming in the swimming pool which might have been overlooked
by the trustees if they didnt have to visit the swimming pool
themselves

but one day they did and it just so happened that one staff

member who used to meet her boyfriend at the pool for a shared lunch hour got carried away by erotic enchantment and was fucking her lover at the side of the pool precisely at the moment that mrs disney followed by a train of trustees arrived

you might think that this would have been an even greater offense to the disneys and their trustees than the hiring of marcuse and wonder that the school survived but this would be to underestimate the charm and persuasiveness of bob corrigan who worked his magic somehow pacified the trustees and ensured the survival of the school

thinking about all this im struck by how telling the story of these events goes so quickly while the events can take days or weeks to unfold the story of marcuse and marthas show took maybe two to three minutes to tell but to prepare the show martha probably ran around for several weeks looking at other garage sales it could have taken her a week just to decide what objects she was willing to unload and then a day or two to install them in the gallery after which it took several days before sandys review came out in the *triton times* another week for martha to write her response and maybe yet another week before the next edition of the school newspaper came out and then a week or two before we arrived at our confrontation in the philosophy department thats practically two months of time in three minutes of telling but even in those three minutes theres an elasticity to the time all the weeks leading up to our meeting go very quickly in the telling and then the night of the meeting in the philosophy department takes almost as long as the account of all those weeks leading up to it but even within the account of the meeting the only part that approaches the real time of the event is when elly presents marcuse with her version of poor peoples art and its this elasticity of time that expands and contracts in our hands like some kind of game of cats cradle in our telling but also in our experience

so driving up i was thinking of when it was that i had time on my
hands and when is it that you have time on your hands its when
youre waiting for something to happen that isnt happening and this
waiting will always go slowly but never so slowly as when what
youre waiting for doesnt seem purposeful or richly rewarding and
it can go so slowly that your experience of time arrives at a duration as
absolute and solid as a block

so i was reminded of a time when i was in college and got a
summer job in a bubblegum factory they didnt know it was a
summer job they were hiring mechanics because their machines
were always breaking down and they needed lots of mechanics to keep
the machines running but they had to train them or at least give
them enough time to learn how to work on these idiosyncratic gum
wrapping machines so they wanted people who would stay with
them for years but somehow i managed to persuade them i was
looking for a career i had gone to an engineering high school and
had worked at a number of jobs that made this seem likely enough
even though i was lying

so i came in for my first day of work and of course the chief
mechanic didnt really know what to do with me its not like he could
have said come with me and led me over to a machine that we could
take apart so i could learn how it worked you see there were rows
and rows of clattering gum wrapping machines at each of which stood
a young woman dressed in white like a nurse dropping little pieces of
gum into the tall vertical chute that a mechanical pusher at the bottom
rammed two by two through two layers of paper and into a tumbler
that folded the paper around them and passed them under a heater that
sealed them with wax melted from a little tub alongside the pathway so
that they could arrive in bright little red white and blue packages onto
a conveyer belt but all these young women were paid for the

number of trays of gum that were wrapped by their machine so
each of these mostly young women moved in a graceful and nearly
continuous dance in which they leaned over to take a wooden tray of
sheets of gum from the huge stack behind them placed it on the shelf
at the back of the machine split the scored gum sheets into long
straps broke these into the individual gum pieces with a few quick
movements of their hands and dropped handfuls of them into the
vertical chute till theyd emptied their trays which they then placed
on a dolly of empties in back of them and turned to take another fully
loaded tray only to begin the process all over again

and this never stopped until one of them shut her machine down
to go to the bathroom for a smoke a move they couldnt undertake
very often without their supervisor noticing so what they
occasionally did was accidentally drop a piece of gum into the gum
pathway instead of the chute this would gum up the works and
bring the machine to a sudden halt and a mechanic to help get the
machine up and running again but the nature of the machine the
viscosity of the gum the excess of sugar powder flying around
produced enough breakdowns anyway but there was nothing to do
until there was a breakdown so the chief mechanic had to give me
something to do and what he did was lead me to a table where there
was something that resembled a very large paper cutter and a huge
stack of amber slabs of wax and what he instructed me to do was to
cut up these slabs of wax into brick size pieces small enough to place in
the little tubs on each machine and fill up the box that stood next to
the wax cutter

it was not a job he took seriously it was not a job i took seriously
we both knew he was just giving me something to do till he could find a
way to work me into a mechanics role still i had to find a way to
make it look good but what was good

i had to make it look like i was doing something serious i start
cutting wax now i know im not doing anything very useful and i
wonder how long am i going to be cutting pieces of wax before i get to
do something meaningful its like being in school im cutting wax
if i cut too much of this stuff theyre not going to know what to do with
it and i have to figure out how to cut an insufficient amount of wax
in the amount of time i have available so that it doesnt begin to spill
out over the box they gave me im looking and i figure i could fill this
box very quickly he doesnt want me to fill this box very quickly
he doesnt want to talk to me for another fifteen or twenty minutes at
least maybe thirty minutes how can i take thirty minutes of wax
cutting to fill this lousy little box in such a manner that it will seem
reasonable i want it to seem reasonable you dont want to look like
youre working too hard because that doesnt look fair to everybody
else on the other hand you dont want to look like youre goldbricking
because that doesnt look fair to everybody else you want to look like
a union worker so you take a piece of wax and you line it up and
slowly you apply pressure to it to make it a precise cut of wax then
you go and measure it against the little wax pots on the side of a
machine so you dont make one too big to fit into the wax pot you
want to make a little wax brick of exactly the right size each time you
cut into the slab and you have this moment in which youre
wondering how long have i been here how long will i still be here
waiting for this guy to say come on lets take apart a machine but he
cant take apart a machine thats running he has to wait for one to break
down because it cuts into what the women are getting paid theyre
getting paid piece work for the work they do so only when a machine
really breaks down can you take it apart and figure out how the timing
chain and everything else works

apprenticeships take the longest time in the world because in

this kind of instruction you have to kill an enormous amount of time
waiting for your instructor to stop what hes doing so that he can
 instruct you so here i am wasting time knowing that im wasting
time as im standing in this refrigerated room under gusting clouds
 of sugar dust not only with time on my hands but with wax on
my hands alongside a growing pile of nice little wax bricks cutting
one piece of wax another piece of wax another piece of wax
 until the time becomes as dense and solid and blank as a block of
 yellow wax

id been a getty fellow since january theyd given me a pleasant
apartment in brentwood and an office in richard meiers great white
castle in malibu overlooking bob irwins curious formal garden and
the pacific ocean living in san diego 130 miles away i would take my
little jeep wrangler and drive up early monday morning for the weekly
seminar spend the rest of the week in los angeles and take my bumpy
ride back home on thursday night if nothing was happening on the
weekend or if elly wasnt coming up to join me for the weekend
the intellectual company was great the theme for the year was
"frames of viewing" and the getty had cast a wide net to consider the
question a net that brought in scholars from neurology archaeology
and philosophy as well as art critics and historians so the seminars
were lively and wide ranging and in april the getty following a
tradition it had developed over the last few years commissioned three
poets marvin bell jorie graham and me to engage in some way
with its theme this was an entertaining commission for me because
id been a fellow since january and had taken part in the seminars and
conferences but also because id never heard either marvin bell or jorie
graham read as it turned out bell read a series of short humorous
pieces that played in and around the theme but nobody got to hear
graham because she developed a punctured eardrum and was prohibited
by her doctor from flying so her smoothly disjunctive poem was read
in an appropriately high rhetorical style by her friend the poet carol
muske out of which my memory fastened on a single concrete image
of a painting by michelangelo pistoletto

how wide

is the

frame

i was taken by the mention in jorie grahams poem of michelangelo
pistoletto because many years ago back in 1969 i was putting
together a show of post-pop painting that included a number of
artists like estes and alex katz malcolm morley and sylvia sleigh with
a few pop painters like wesselman and lichtenstein and warhol and i
wanted a pistoletto for the show this was 69 and i was beginning to
think that we had to take another look at representation because
somehow the frame of the art worlds serious concerns seemed
somewhat narrow to me and at the time i was the director of the
gallery for the university of california at san diego and i wandered
into his dealer who was jill kornblee an old friend and i looked
over what she had there because she had some of the paintings from
a recent show and i saw a very modern looking modern that is it
felt very sixties looking there was a young guy standing in a
contraposto wearing white jeans very tight white jeans looking as
though he had just come out of *blowup* i said i want that one jill
you cant have it why cant i have it she said because harry
abrams is having a party and he owns it he wants it for the 133

opening of his new loft she said but you can have this one and
 she pointed to a sparklingly startling painting of a beautiful naked
woman standing and talking on the telephone it was a painting in
 that the figure like all pistolettos figures was painted from a
photograph on some kind of paper affixed to a burnished steel surface
 and it was this beautiful naked woman having a graceful conversation
on a white telephone now a white telephone was the marker of
 italian sixties modernism so i said why can you give me this one
 well she said david its the only one i have left the others are all
 going to a major show at the albright knox i said "and theyre not
taking this one?" she said "the albright knox cannot show nudes"
this is 1969 and the albright knox cannot show nudes? she said thats
right david and so i came back with a pistoletto that was more
 pistolettoish more antonioni-ish than any i might otherwise have
 gotten
 now the reason im thinking about this is that i was thinking
about the peculiar frame of mind that the trustees of the museum
 must have been in to exclude this rather startlingly characteristic
work i mean they had a very tight image of a museum where you
cant show nudes but then i reflected that there were other tight
visions in the world of serious art as i found out a couple of years
 later when i found out that the whitney museum was not allowed to
show photography i found this out when marcia tucker was putting
 together a david duncan show and there was something of a scandal at
the whitney because the whitney museum had been chartered to
show american art i thought to show *american* art but actually
apparently to show american *art* and photography wasnt art
 painting was art and so when i reflected upon this a couple of
years later i could imagine how the albright knox in the early part
134 of the twentieth century in america had found it inappropriate to

display sexy nudes as art even though titian had existed long before
though i wondered what would happen if they did a titian show
would they have been forbidden to show any titian with an unclothed
woman

this sort of persistence takes a certain kind of concentration an
intense concentrated sense of the frame that holds you together
in a way and lets you go on in a manner that youve been going on
all your life or for the last ten minutes or the last thirty seconds
theres something about this kind of concentration something i
experienced this morning

we were at the hotel on sunset elly and i we were coming by
car we had our jeep and we managed to get out of the driveway
into the street in spite of the horrendous traffic and we were coming
up sepulveda and i had no idea how many people wanted to see
saenredans mournful church interiors in one day i assume thats what
they were all gathering for and as we approached the getty going
north on sepulveda and got closer to the getty entrance there was
this incredible number of cars backed up in the entrance way
extending partially into the street and blocking one whole lane of the
southbound traffic which consisted mainly of cars waiting to get into
the getty though it included cars that were not intending to get into
the getty that had somehow neglected to get out of the inner lane

now the people at the getty who run the entrance and you may
be familiar with the way they work work reasonably slowly and
they have to work reasonably slowly because you might be a terrorist
carrying a bomb you might have something under your jacket or you
might not have a reservation and they work slowly because theyre
only human beings

and then there are people who pay with credit cards and then
maybe a credit card doesnt get taken by the magnetic strip reader

and these things happen all during the wait to get into the getty so
both the gettys entrance lanes were blocked

now as everybody knows one entrance lane the entrance
lane slightly further to the south is mostly for staff and scholars
and people involved with the getty and the other one is for visitors
casually coming in and this makes a lot of trouble because there are
many more visitors than staff and some of the visitors take notice of
this and pull into the relatively emptier inner lane only to be shunted
shortly afterward back into the visitors lane before they can approach
the admission kiosks the result of all this was two lanes of entering
cars extending out into the street where they completely blocked up
the inner lane on the southbound side and made it equally impossible
for the cars in the turn lane on the northbound side of sepulveda to
make their left turn into the entrance when the traffic light favored
them with the result that there was also a long line of cars in back
of them waiting to get into the left turn lane where nobody could
move and im at the back of the turn lane on the northbound side
and i realize its going to be hellishly time consuming though im
reasonably patient

but elly says oh my god open the windows were going to suffocate
in here before we get in while im looking ahead and seeing that the
cars at the head of the turn lane are very timid theyre afraid to turn
in at the right moment because theyre worried theyll be stuck out in
the street further impeding the traffic from the north

but generally people are keeping clear and only one lane is
really impeded

finally weve advanced to the very front of the left turn lane to get
into the getty and were waiting for the light to change and were
watching the cars come rushing down when somebody in a car in the
inner lane on the southbound side waiting to make the turn in became

extremely dispirited with the wait she really must have felt very
concerned about the wait

 she had this sparkling little silver volvo there were four people
in the car and they were all looking concerned about it then a smile
broke on her face and she started to turn to her left as she realized
she could go if she could get there into the parking lot across the
street from the getty because on the other side of sepulveda there is
a little open parking lot and she blithely turned slowly and in
stately fashion she turned her car and headed across the adjacent
lane

 at the moment that she was doing this at enormous speed a
snappy little red volkswagen probably on its way to wilshire heading
for ucla was tearing down the lane racing toward her she never
noticed it i saw it drawing close as she continued in her stately
way moving gradually across the lane and i was sitting there
waiting trying to figure out whether i should blow my horn to warn
her of the approach of this rapidly advancing red volkswagen or whether
that would distract her even further and make her do something even
more maniacal what could she do?

 i figured if the red volkswagen hit her volvo it might spin into
my car i looked out to my right and there was a very good chance
of her hitting us if the volkswagen hit her at that speed of course it
would depend on the place and angle of impact

 im beginning to
contemplate this like a billiard table trying to figure out what would
happen when the red volkswagen hit the little steel colored volvo
and im trying to see is there a car is there traffic coming up on my
right pursuing the pathway north past the getty because if that lane
is clear maybe what i should do is bolt into the little parking lot on my
right

my problem was solved by the good brakes on the little red
volkswagen the little red volkswagen came to a screeching halt
but the woman driving the silver car making the sedate turn never
noticed she didnt hear a sound she didnt hear the brakes she
didnt see the other car she smiled blithely and drove right across
three lanes of traffic into the parking lot across the way i took this
to be a profound artistic commitment to the frame
and i thought about the way this kind of commitment works
because we were talking the other day several of us were having a
conversation about poetry the other day at the getty and the
conversation got around to music because i had brought up john cage
and his original generalization of the notion of music finding its
fundamental possibilities its most elemental possibilities in the
contrast between sound and silence that is a sound might be
made manifest by emerging from a ground of silence and its
manifestation would be the fundamental act the fundamental act of
the composer would be the decision to manifest or not to manifest
or maybe in a more cageian manner a piece of sound would
simply replace a piece of silence thats all very well but in thinking
about it i realized it requires a very rigid frame of some form or
another to determine where the sound is you have to be able to
distinguish between the sound and the silence and at the margins
this is not very easy its not so easy with morton feldmans music
in feldmans music sometimes you can hardly hear it at all and when
you hear it what you may be hearing is simply background noise if
you listen to feldmans music on a recording and dont play it back on
the very highest quality audio equipment you cant listen to it at all
i remember hearing him say once we were on a panel at an
anti–vietnam war forum and everybody in the audience was yelling
at the avant garde that we were letting them down we hadnt been

doing enough politically against the war it was the excited left and
they were complaining that we were letting them down and there
was a point to it i suppose but when it came his turn to speak morton
said "look im against the war but im an avant garde composer and i
like very soft sounds and thats what i use in my music thats all i can
do i cant help it"

but the edge between sound and silence is very problematical
which means that for the kind of work cage was pointing to he had to
present it within a very tight frame a durational frame that you
simply accepted arbitrarily

but theres more to it than that it occurred to me that framing
becomes a major issue because you have to be able to identify a sound
as a sound to identify it as a discrete sound to have a musical
experience of it as a sound you have to be able to separate it from a
sound continuum if sounds within the continuum change if youre
hearing a variety of sounds within a sound envelope

im not speaking
of sounds that are easily identifiable like the screech of the volkswagens
brake the screech of the volkswagens brake is identifiable because its
a piece of a recognizable real world event and the event structure
allows you to frame it but if youre a composer using a computer and
oscillators to generate sound events synthetically sound has a variety
of parameters frequency timbre amplitude and if youre
dealing with noises there are frequency bands and timbre packages
which may not be easily defined though they can be easily generated
but can they be remembered one of the worst problems of electronic
music is whether youre hearing a sound again its not always clear in
this music that you can always distinguish an event as an event
distinguishing events is not so easy especially when the events are
moderately unpredictable not all events are easily recognizable or

intelligible and if theyre not they may not be recognized as events
at all

now the notion of an event is psychologically the center of our
being we recognize objects and events from infancy in a certain
sense we recognize them because what they mean to us is the loss of
the milk the mother has taken her breast away her beautiful face
has disappeared or it comes into view or rather it reappears so
we recognize our mother or our father as an object very quickly as
soon as we recognize the regularly repeated disappearance and
reappearance of the father or the mother this repetition gives us an
event structure "you kept going out of the room!" "you mean hes
going out of the room?!"

this gives us the room as a background weve framed it and
its not even an object but what surrounds an object and lets it stand
out so weve framed these objects and actions and weve learned to
frame these objects through actions and of course we dont learn it
the way we learn things in school we may be hard wired to learn
this we may have a neurological structure that makes it possible for
us or impossible for us not to frame not to give a sharp definitional
edge to something and to the breakdown between the something
and the nothing the contrast between whats in front of you and whats
not in front of you is very sharp especially if its moving the
first thing that infants can see is motion the thing goes by in the
dark and its gone they see movement before they see anything else
which from an evolutionary point of view is a very good idea the
one thing a young animal may have to do is get out of the way of
rapidly moving animals or things youve got to be careful and
carefulness is built into the structure of humanness but probably
into chimpanzees also and maybe all animals with visual centers
but this kind of perceptual understanding of objects and events

means that the representations of objects and the recognition of events
or stories or narratives are grounded in our being but this recognition
comes at a price it comes at a price because it means that we have to
concentrate on those things at an expense at an expense of the loss
of other things you get nothing for free if you see one thing you
dont see another unless you make a very definitive effort to try to
 i was thinking about this because a computer artist visited our
campus recently and he was trying to provide the experience of a 360
degree panoramic vision for human beings theres something
wonderfully comical about this because in a literal sense its not
possible the simultaneous apprehension of a 360 degree space is
prevented by the structure of your body because your eyes are in
the front of your face and all you can do is assemble the 360 degree
space conceptually
 you can present the video image of all 360 degrees on multiple
screens very rapidly juxtaposed or you could overlay them on each
other but you wont get a 360 degree surround experience completely
synthetically and instantaneously because youre not capable of
experiencing it im not either dont feel terrible about it none of
us is capable of this ghastly situation of imagining it but theres
something funny about his idea its like imagining that by letting
you see the unseeable he was creating out of the unexperienceable
a new art experience
 but art experiences are created about not seeing about what you
want to not see in order to be able to see something else and
maybe thats what we mean by an experience
 i was thinking of something like this when i was trying to explain
to myself what it was about his life that i didnt understand when we
had dinner with my father in law a couple of nights ago my father
in law is a ninety-three year old man who is in perfect mental health

the only thing you might suspect about his mental health is that hes constantly working at mathematics

hes not a professional mathematician who pursued mathematics during his working life hes a mathematician by inclination and devotion when he was very young he was considered something of a mathematical virtuoso

this was in poland which at that time was in possession of vilna which is now vilnius in lithuania he was at the great polytechnic school there and he was destined for a great role in mathematics but many things happened and it never worked out so he came to the united states his life changed and he never worked at mathematics professionally

but this didnt mean that he lost his love for mathematics and he was always eccentrically interested in numbers in his later life he was married to a very demanding woman his second wife who persuaded him to retire from his job in the dress business where he was a skilled technician making by his standards very good money he didnt care much about money he was making reasonable money but his wife wanted to retire to florida

florida is a place where you have tall palm trees that give no shade its a humid but dry oasis that was once under water from which the waters have now been conveniently pumped out a place old people go to die slowly and comfortably though they dont regard it as that my father in law didnt regard it as that and of course theres more to florida than that but the fact remains that a large part of the southern florida saucer is a vast retirement home but when my father in law retired he still had lots of energy and no desire to spend his days sitting around the pool with his wife or his pinochle cronies so he found a job a part time job at a dog track because he was always interested in numbers and liked gambling but that didnt

last too long because his wife required more of his company at the
pool so he took to going to the jai alai games to which he could bring
his wife and pay attention to the numbers

he didnt really know the rules of the game he had no idea how
the game was played but he observed that the players were all
assigned numbers and at the end of each game they announced the
winning numbers

and each day the local newspaper published the list of the days
winners with their numbers and by carefully studying the
newspapers he began to see a pattern in the numbers so without any
· idea of what the players were doing except generally running around
swatting at a ball with a basket attached to their arms he discovered
a pattern to the victories

as certain numbers remained unvictorious for longer periods of
time their probability of imminent victory increased markedly so
he could go with his wife and a list of likely numbers to the jai alai games
bet without the slightest idea of why or how the players wearing the
favored numbers would win and generally walk off with a noticeable
profit so he was by his character oriented toward numbers and
toward discovery and invention because he was also an inventor

for years he struggled to invent the perfect card shuffler this
was something i never understood everything he did seemed to have
this oddly placed image of reality that i found hard to frame the
card shuffler you could design a mechanical shuffler that had some
kind of rotating or tumbling reservoir you could crank by hand or
drive with a battery that would reasonably scramble the order of the
cards and spit them out into some kind of reservoir reasonably shuffled
but he had set himself rules esthetic rules his shuffler had to have
no moving mechanical parts and it had to produce a perfect shuffle
every time you dropped the cards in no matter how perfectly the

suits were arranged you would have to get a random distribution when the cards came out

he finally got a patent on one it was a beautiful little plexiglas tower composed of three little boxes that fitted neatly into each other you dropped the cards into the top section which was a little box containing three upright angled pieces of plexi that cut the deck into four smaller packs as the cards slid down into the second box where they were further subdivided by two angled t-shaped plexi pieces and dropped when you shook the tower gently into the bottom box where voilà they were shuffled and it kind of worked though not into a perfect shuffle because there were many things that prevented this from happening including the viscosity of the cards the humidity of the room or the skill with which you dropped the cards in and jiggled the boxes around but he had a patent and he was working at improvements when he got involved in another project

somehow he got the idea that he could solve a problem that mathematicians have long considered unsolvable he wanted to solve and find the roots of high powered polynomial equations of any degree a simple polynomial equation is an expression like $x + y = 444$ thats a linear polynomial or a polynomial equation of the first degree in fact he was more ambitious than that he thought he could find a way to solve any polynomial equation of any degree so instead of x and y you might have x to the 435th power + y to the 434th power and that wasnt the half of it he said he was on track to be able to solve any polynomial equation of any degree you mean i asked him for any kind of powers?

for irrational powers like $\sqrt{3}$ or transcendental powers powers like π which is 3.1416 . . . and so on forever yes he said all of them

look i said sol maybe youll solve some of the higher power polynomial equations but theres a proof i know he said abels

proof says you cant get a general solution for polynomial equations
 higher than the fourth degree
 i can do it ive got a way its almost perfect he said i said whats
that he said i think ive got a way to find a root of any equation
no matter what power rational powers irrational powers doesnt
matter ive got a way im almost there
 now this may sound trivial to find one root of an equation with a
variable to the 434th power but if you can find one root of that
equation you can extract the root and get an equation to the 433rd
power and keep repeating the process until youve extracted all the
roots and youve solved the equation it seemed to me an outrageous
proposition how could you do it besides how would you know
that you could do it lets say you could solve any equation you tried
to solve but you cant test every equation so how would you know
youve succeeded
 this was not the way he viewed the problem every night he
worked late into the night solving equations he would solve one and
then another and then he would come to some he couldnt solve and
he wasnt quite sure why though he thought he would get them
eventually but i said sol maybe whats happening is youve solved
some of them maybe theres something about the ones youve solved
theres a family of them and they have a family relationship if you
could define a technique and define the group that youre solving them
for you may have discovered a brilliant algorithm
 he knew he had a great idea but he didnt know what an algorithm
was hed learned mathematics in polish and he didnt know what the
word algorithm meant eventually i explained it to him but he shook
his head and said i go up to my room every night and i dont watch the
television and i dont read a book i work at problems all night and
when i wake up in the morning i cant wait till ive had breakfast to start

working again im ninety-three years old and it keeps me alive to keep
working like this and ive almost got it im very close

i thought that was wonderful still i said sol while youre
working away at the total solution it could take longer than you
think for the complete solution and in the meantime you could have
this brilliant algorithm for solving a whole family of difficult problems

you think that would be something? i dont know for sure i said
but it sounds like it all youd have to do is figure out the difference
between the equations you can solve and the ones that you cant solve

"youre right" he said "youre right theres only one problem
i dont remember the problems i cant solve" "but you write them
down in a notebook youve got them in a notebook youve got a
notebook for the ones youve solved and a notebook for the ones you
didnt"

"i write them down the ones ive solved on pieces of paper
ive got them on pieces of paper" "and the ones you cant solve?"
he shrugged

"i throw them away"

he took me to his desk and the drawers were overflowing with
scraps of paper pieces of envelopes parts of old bills deposit slips paper
bags and old memo pads covered over with letters and numbers in a
jumble of computations

"sometimes i tell myself i should put them in a book but im too
hot working and i have no time and then im tired and i go to sleep
and in the morning i forget because i want to start on new problems
so i put them in the drawer and there they are but i think im
almost there"

i looked at this chaos and i asked myself what does it mean that
he doesnt keep a notebook to see what hes doing and i figured

maybe im looking at this the wrong way maybe my frame is too

narrow maybe this is the scheherazade story scheherazade never
stopped talking and thats how she stayed alive sol is ninety-three
years old it may be that hes beginning to identify his life with the
act of working out these solutions every night if he found a complete
technique for solving any and every polynomial equation he would
never have to solve another problem

it may be that i have to change my frame and see sol not simply
as a mathematician working at a difficult or even impossible problem
but as a mathematical scheherazade solving problems to stay alive

so once again its a matter of the frame of how to frame an
event it seems easy as simple as the fall of a glass of water a
glass of water falls to the floor and smashes it slips through my
hands and smashes

but its not a glass of water its a whiskey sour
you ask for a whiskey sour and the bartender hands it to you but the
condensation on the outside of the glass produced by the ice makes it
slippery so it slides through your hands and falls to the floor where
it smashes and there you are the ice the pieces of glass the drink
on the floor and youre slightly embarrassed by all this as you wait
for the bartender to get you another drink

we had an event you asked for a drink it was handed to you
it slipped through your hand and smashed on the floor but why are
you embarrassed why did it slip from your hand

it slipped through my hand because just as he handed it to me i
looked up and saw someone over there implausibly at this party
in this fifth avenue apartment house i saw a woman i knew and there
was no way she could have been there it was an old girlfriend and
i was so surprised at seeing her that i failed to take hold of the glass
which slipped out of my hand and smashed and i looked down at
the floor and saw the glass and the whiskey on the floor and i looked

up to see my girlfriend who i wanted to go say hello to and she had suddenly turned away and was headed for the door shed been standing there before in a crowd of people and then she was out the apartment door

i left my drink on the floor and started walking after her following her out the door figuring before she goes away i should exchange hellos with her i get out the door and shes already in the elevator going up to another floor i push the button so the elevator comes back down and i go up i figured by the time i got out i would have lost her but actually shes way down the hall turning into another apartment i see what apartment she enters and follow her down the hall i figure ive gone this far i may as well say hello to her i knock on the door and a woman comes and opens the door and shes wearing the same dress but its not my girlfriend at all

its a eurasian woman a beautiful eurasian woman who doesnt look the least like my girlfriend

now how did i imagine it was my ex-girlfriend

but she smiles like shes expecting me she says come in i come in and as i come in i see that in the middle of the room there is a large roulette table she says pick your number i walk over and i look at the roulette table while she stands there silently watching i look at the numbers

the numbers are strange $\sqrt{3}$ π ε α δ σ i pick ε somehow thinking its the natural log e

so i pick ε a transcendental number my croupier claps her hands the ball goes round and round and it stops on ε she claps her hands again and an elderly gentleman in a tuxedo without a tie comes out of a back room carrying what looks like a violin case he comes in takes out an old violin and starts to play he plays in this

odd broken way for moments he plays brilliantly hes playing
a caprice a paganini caprice which you shouldnt play unless youre
in full control of everything in the world he starts playing this
paganini caprice and for a few bars its brilliant and then it goes
 very bad and then he starts again and hes playing the same
paganini caprice and again it starts brilliantly and this time goes
 fourteen bars further before it breaks down he puts down the
violin and starts to cry hes weeping there and a little girl comes
out and takes him by the hand and leads him out of the room

 i look at my croupier

 she says "winning is *also* losing"

ben weissman was putting together a writers series for the armand
hammer museum in the summer and wanted to know if id be willing to
do a talk piece in july i said sure as long as i could do it on july
14 id always wanted to do a talk on bastille day because the idea
of liberation still appealed to me but when the program came out it
seemed i was scheduled for the twenty-first i thought about
protesting but decided there was a message in the mix up so i decided
to forget about liberation which often turns out badly anyway and
thought about the hammer museum its located on wilshire close
to ucla which its now a part of and i considered how often and
repeatedly id traveled back and forth to los angeles in the years since
we moved to san diego

when we first came out here san diego seemed very far from los
angeles to reach the great metropolis you had to drive past long
stretches of empty orange county citrus groves and hop and strawberry
fields sheltered from the coastal winds by thin stands of ragged
eucalyptus but gradually this changed one day a sign appeared
over a new exit from the 405 it read MISSION VIEJO

implausibly because there was no mission there or anything else
weird glass buildings began to appear in the hop fields hillsides were
flattened for cookie cutter housing and after a while orange county
began to look like an l.a. suburb meanwhile in the south encinitas
gave up its hillside flower fields for "cape cod" style condos scruffy
oceanside took down its tourist welcoming sign COME TAN YOUR
HIDE IN OCEANSIDE and we were all los angeles now from wilshire
boulevard down to the mexican border

what

happened

to walter?

i came here with something on my mind something ive been
thinking about for a while and thinking about it i havent been able
to resolve it its a question thats been addressed by a lot of people
whether there is such a thing as repetition and how we should think
about it if there is such a thing and even if there isnt

now ive thought about it a number of times which already
suggests there is such a thing but its an old problem that goes back a
very long time in european thought if you consider turkey part of
europe because herakleitos lived in ephesus on the western coast
of turkey during the persian domination toward the end of the sixth
century bc which was a long time ago and herakleitos observed
that you can never step into the same river twice this made a lot of
sense to me because it seemed to confirm a conclusion id come to long
ago that experience prepares you for what will never happen again
but how does this square with kratylos' subsequent wisecrack you
cant step into the same river once its always good to have a smart
student wholl push you further

which is what the kratylos crack seems to do the river changes

so fast that by the time you step into it its already a different river
 but when you think about it the kratylos pushes the herakleitos further
than that in fact it pushes it over a cliff because it implies that you
 cant experience anything once because to experience it once you have
to experience it twice which kicks the question from an argument
 about repetition into an argument about experience
 consider an infant trying to engage with the alien things out there
 in the world around it it sees something out there it might turn
out to be its toe but at this point in time the infant doesnt know that
 its toe is its toe eventually it discovers a relation it feels it when
it moves it sees a hand its hand reaching toward it feeling its
 hand reaching and then touching and its toe feeling something
 touching it but all this cant happen the first time around
 a child isnt born with a map of its body and it doesnt know its
hand is its hand until it sees it several times and connects its movements
 with the feeling of its movement and seeing it move it takes a few
shots the child reaches may fail to reach reaches out randomly
 grabs and then it feels something else and it has to process this and
 recognize it the next time as the same thing it saw before but its
 not exactly the same thing because its the other foot now the child
may not know its the other foot it may not yet know it has two feet
 because its early in its career
 later the child will be a philosopher and will know perfectly well
 or maybe because its a philosopher the child will not be certain that its
the other foot the point is that kratylos positions the argument in
 such a way as to start the debate on whether we can see anything once
at all and whether repetition however impossible to imagine may
 be necessary for any apprehension of reality at all
 the problem doesnt go away nobody seems to know how to deal

with it what we do know what we come to know now about the
brain which is not the mind

nonetheless the brain and the mind have
a sufficiently close relationship such that if you cut somebodys head
off he cant think

beyond that the connections though illuminating are somewhat
more uncertain the mind is not the brain and the brain is not the
mind but the brain seems to support all the activities of the mind we
recognize as taking place and one of the things weve come to
recognize is that the inputs of the sensory system are very
strangely dissociated that is to say if i notice your green shirt
if i notice that you have a green shirt on and youre leaning on your
elbow the visual information about your color and shape and
location in space are registered separately by differentially sensitive
parts of the retina and transmitted to different parts of the brain
the signals for color and shape are not initially processed in the same
place and motion is not processed in the same place as either of
these two so in effect everything that we see is disassembled in our
sensing before its reassembled in our seeing we no longer have the
same model of seeing that we used to have the eye is nothing like a
camera

or its only a little like a camera in that it has a lens that focuses
the light rays reflected from the objects of the world and transmits
them to the retina but thats it because these visual impulses are
registered selectively by differentially sensitized cells in the retina and
transmitted in a series of discrete impulses to different parts of the
brain which has to have some organizing system to reassemble them
for the mind to allow me to recognize that the green belongs to
your shirt and the angled shape is the elbow that belongs to you sitting

there in the second row we dont know how thats done when i say
we i mean nobody knows how its done

nobody knows how the organizing system works some cognitive
psychologists and neurologists can point to certain places in the brain
where this might be done and are careful to say might be done
because various conditionals and subjunctives are necessary to honestly
express the doubtfulness of what we know which coming from an
early background in science always seemed easier to me than it has
apparently been seeing that the career of science however
brilliantly successful its projects appears at the same time to be a
history of error since any theory proposed by any scientist will
eventually be disproved

now one might say that there is a cumulatively positive
achievement in each disproof that each time you disprove something
you improve the state of our knowledge so that gradually we know
more and more and are ignorant of less and less

well maybe and maybe not but generally no particular scientific
judgment has the kind of fixed validity you can come to rest on as
we just found out about the popular hormone replacement therapy
that was known to protect women from the hot flashes sweats and the
vaginal drying of menopause to counter osteoporosis and in the
imagination of its most enthusiastic advocates to reduce the risk of
heart attacks and to act against almost all the effects of aging including
alzheimers disease

but now along comes a double blind study of nearly twenty
thousand menopausal women conducted over the course of a year
and it shows a $\frac{3}{10}\%$ increase in the combined incidence of breast
cancer heart attacks strokes and blood clots in the group receiving the
combination of estrogen and progesterone over the control group

but what does that tell you the drug combination still works

against the distress of menopause and its action against calcium loss
remains unchallenged no other benefits were documented and there
was a very slight increase in quite severe problems but does a $\frac{3}{10}$%
increase in the incidence of problems translate into a $\frac{3}{10}$% increase in
risk for any woman taking the medication and if so is it a bearable
risk and then what generates the risk the drug combination?

no
increase in risk was seen in a group of postmenopausal women taking
estrogen alone
was it the manner of administration or the
preparational form of the medication natural or synthetic
progesterone the questions go on
this is also the way of science the more we learn the less we
know and what we know about the brain is even more uncertain
because the organizing mechanism that puts green angle elbow
person back together again into the person in the green shirt leaning
on his elbow in the second row is completely unknown and we
certainly dont know how we can turn away and remember him and
his green shirt when were no longer seeing him because we dont
know about memory we dont know how memories are stored if
theyre stored and in the course of the discussion i was having with
myself i was thinking about the question of memory i was thinking
how we often speak of the value of experience and its experience that
interested me because i wasnt sure i knew what it was
when we speak about experience we imagine that memory has a
positive value but the term memory overstates the case people
when they speak of memory imagine it vaguely as a kind of neural
storage bin maybe like a filing cabinet the way they think of a
computer storage system where each memory has an assigned place
in a distinct folder in a particular drawer of this imaginary filing cabinet

the trouble is nobodys ever been able to find these bins though when
i was in college there was a great physiological psychologist named
donald hebb who proposed that memory which had long been an
embarrassment to all investigators could be located in what he called
reverberatory circuits that is electrical impulses corresponding to
perceptions could be shunted into a self enclosed circle of neurons
around which they would circulate till they could be recalled to be
acted upon by the motor system or integrated into some higher level
cortical activity it was a nice idea and it created a fair amount of
excitement at the time but nobody could find any of these circuits
that lasted longer than a few seconds and since that time back in the
1950s in spite of all the great technological advances in the study of
neurology and psychology nobody really has had anything like a
concrete idea of the neurological basis of memory so were thrown
back as we often are on the phenomenological and the linguistic we
have to examine experience from within experience to find out what
kind of sense we can make of it

now one thing we always seem to mean when we use the word
"experience" is direct sensory apprehension direct contact with
something rather than reading about it or hearing about it thats
the primitive way we talk about it we say hes an experienced driver
which means that when you put him in a car hes done more than read
the manual because if you take someone give him a list of driving
instructions and send him out on the road god help you if youre
anywhere near him learning to drive is a complex activity which
everyone in los angeles knows about los angeles has generated a
demonstrable evolutionary development the automated centaur
nearly everyone in los angeles is attached to a car for the better part of
their lives to get from anywhere to anywhere in los angeles you need
a car because if you try to walk they might arrest you

it nearly happened to us many years ago it was around 1968
and elly and i were staying with a friend in beverly hills and we
were old new yorkers so we decided to take a walk we had a one
year old child in a stroller and we ambled slowly walking and talking
to each other so we didnt notice that the streets were completely
empty of people nor did we notice that a squad car was slowly
trailing us as we walked until it pulled up alongside of us and the
cop on the curbside asked

"where are you going"

"were not going anywhere were walking"

"where are you staying"

apparently it was such a shock to see somebody walking in beverly
hills that they were prepared to interrogate us but after a couple of
questions they were satisfied that there really was a baby in the baby
carriage not a submachine gun and that we were simply taking the air
so they let us go but they said you have to be careful

"be careful?" i said "of what?" they said "well be careful
people dont usually walk here" and i guess they were warning us
that if we crossed the street we might be killed by the oncoming
traffic because the lights are organized largely for the convenience
of the people in vehicles not people who need to cross the street
which we noticed again this afternoon as we waited endlessly for a
green light to cross the broad avenue in front of this building and
then had to wait for the little white manikin to appear in the green
light which signals that you can cross though cars may still be
turning in from the cross street while youre trying to scurry across
before the little white man in the light disappears and this was also
an experience that remains somehow as part of a body of experience
in a memory you can draw on almost like a bank account because
here experience refers to the memory of events and you have to be

able to draw on the memory of past events to be able to do almost
anything requiring a skill or a strategy to drive to make love to do
anything at all to swim any activity you undertake you have to
be able to draw on a repertory of previous engagements with similar
situations you have to recall having been in the water

if youre an adult and youve never swum and somebody tells
you how to swim and then you go into the water youll be surprised
the water will be colder than you thought and youll start to sink and
youll think that it wont hold you up and you will sink if you dont
relax and let the water do its job but its hard to relax and believe
that youll float if its your first time in the water no matter what
they told you in physics

im trying to imagine this because its a long time since i didnt
know how to swim i must have been about ten years old when i first
learned to swim and i remember lying down in the water and being
filled with anxiety

so what i did to allay my anxiety was to find a couple of old
gasoline cans the kind you could fill with a gallon of gasoline when
your car ran out because i figured a can filled with a gallon of air
would be lighter than a gallon of water and would float and help hold
me up i took the two cans and went into the surf and the two cans
actually did keep me up and i felt so confident floating comfortably
on the waves with my two gasoline cans that i began to relax i got so
confident that i let go of one of the cans and i still floated and i was
so confident and relaxed i let go of the other can and i was still floating
but i found this out in the water if anybody had told me this i dont
think i really would have believed it not in a concrete physical way
water is somewhat different when youre in it than when you think
about it

there is in fact nothing in the physical world that behaves precisely

as its described because descriptions are linguistic or diagrammatic
simplifications and dont represent all the concrete events you experience
when you actually do something

now of all the philosophers i know the only one who tried to
make a case for the meaning of experience is john dewey dewey
actually tried to think it through although his most thorough
thinking through took place in a very special situation in an attempt
to describe the experience of art which was not an activity he was
very knowledgeable about but he was knowledgeable about human
activity and he proposed that art making was very much like any
other form of human activity and that at its center is the experience
it provides you with in order to describe this he had to work out his
idea of what an experience was and this turned out to be a profound
idea a very beautiful notion that an experience a real or integral
experience has a narrative form it has a beginning a middle and an
end he supposes that all experiences are generated by a kind of need
or desire as he sees it if you dont need or desire something you wont
experience it fully at all and he distinguishes between what he calls
full or integral experiences and partial or chaotic experiences that
dont involve full self awareness and these dont count at all for dewey

he says look suppose you go to a french restaurant thats
supposed to be a wonderful restaurant and youre all set to have a great
culinary experience youre waiting for the first dish to arrive youve
selected an *hors d'oeuvre* and youre waiting for it to come you
could be terribly surprised because in spite of the candlelight and the
sparkling tablecloths the paintings on the wall the waiters all speaking
their earthy dialects the frogs legs just dont taste very good they
taste like tough chicken thighs and theres nothing more banal than
overcooked chicken thighs so this is a bad moment a small personal
tragedy but you still have hopes for the entrée you boldly order

boeuf bourguignon but it comes back sour and unpalatable the
wine is past its prime and the beef is stringy this is very disappointing
but youre still trying to find some of the satisfaction you imagined
or hoped for so now youre at dessert

you order an apple and some brie what can they do to an apple
and they didnt make the brie your luck turns around its a
marvelous apple firm and sweet with the fragrance of its blossom
and a luscious creamy brie its a partial retrieval youve snatched a
small satisfaction from the debacle of the meal this is an experience
you will never forget its hopes and its fears its great defeats and
its final small victory next time you go to a french restaurant youll be
wary of the frogs legs and maybe youll avoid the boeuf bourguignon

this is of course a kind of esthetic experience but dewey isnt
satisfied with this he sees all real experiences as esthetic but hes
particularly interested in active experiences in most cases hes talking
about somebody trying to do something and pushing his argument
further he offers a wittgenstein-like example

imagine a stone he says on top of a hill it gets dislodged
somehow and starts to roll down the hill but let us imagine one
more thing that the stone takes an interest in its fate has a desire
to come to a safe resting place somewhere at the bottom of the hill
that it wants to come there and will judge every obstacle along the way
as something to be overcome this stone dislodged somehow in los
angeles by a slight earth tremor that shakes it lightly it starts to
roll slowly down the hill

it approaches the first larger crag and tries to shy away from it
but slams off it skinning its shins so to speak and from there
slides into a little gully that accelerates its descent then every
boulder and every fold in the landscape becomes part of its experience

till it finally comes to a secure haven at the bottom of a little ravine where its safe until the next rains come and wash it out into the sea

now of course this is a fantasy but according to dewey this is what all experiences are structured like and this is a very appealing model but im not sure that it makes adequate sense im not sure it works this way because it suggests that every experience comes fully narrativized that as something is happening our consciousness fits it into a narrative form saying now im at the beginning this is the turning point and this is the end this is certainly possible but not necessarily so

maybe its only after everythings over and the experience is no longer present when were trying to recall it that we fit it into this narrative form which is sometimes hard to do or hard to do when we first start to recall it when we may only recall a fragment of the experience or a single image but even then is there a place where i store stories like a comic book rack and how do i get a story out of my memory when i recall an experience does the story come out whole i mean is the story stored somewhere complete from beginning to end like a film script think about how you call up the memory of an experience

try to retrieve a memory and try to think about it you know all stories have something in common though theyre not necessarily the same

so once again we come to the notion of repetition but in recalling you dont start at the beginning you may start at an image in the middle

you come to a bridge so lets imagine coming to a bridge

my friend jean pierre gorin a french filmmaker an american filmmaker who used to be a french filmmaker he was the young

partner of the somewhat older jean luc godard back at the end of the
sixties hes been teaching at the university of california san diego and
is a longtime colleague of mine he was in the bay area seeing about
a feature film he had written a script for and was seeing someone in
berkeley this was the seventeenth of october 1989 and it was the
day before i was supposed to be doing a reading at fort mason in the
marina district of san francisco

 id been teaching i remember how id been teaching and driving
home i figured id watch the third game of the world series and when
i got home i turned on the tv and im listening to al michaels and this
other guy in the broadcast booth chatting for a moment when the
booth suddenly shakes

 al michaels says "i think this an earth . . ." and the screen goes
black and its a while before the tv comes back on because this was
the loma prieta earthquake

 now jean pierre was in berkeley planning to drive over to san
francisco to visit a film friend and talk with him about one of the
festivals so hes in his car and hes driving to the bay bridge its
october 17 and hes driving to the bay bridge and hes a few blocks away
and he says to himself "you know i should visit alice" alice is his ex-
wife thats alice waters of the famous nouvelle restaurant they
were married for a short while but they remained friends after they
divorced and he helped supply her with fresh vegetables from an
organic farm called chinos in san diego and now he was right up close
to the bay bridge when he decided "im going to go visit alice" so he
turns the car away and as he turns the earth starts to shake later
he found out that the bridge collapsed moments after he turned away
it was a very substantial collapse in which a couple of cars fell in and a
bus filled with buddhists very nearly went down or at least according
to the story i was told

this group of buddhists was on a bus coming from the other side
of the bridge i suppose on the way to some monastic retreat in
berkeley and the bus was very silent as the driver drew up close to
the bay bridge and then just as he was about to get onto the bridge
he hears this strange abrasive sound coming from the back of the bus
and figures something happened to the transmission so he pulls to a
stop and cuts off the engine but the sound continues he turns
around and its the buddhists chanting and he turns back just in time
to see the bridge and the car in front of him go down

now we may suppose this sequence of events must have been
deeply experienced and deeply and somewhat differently encoded in
the memory of the buddhists and the driver for the chanting
buddhists this might have seemed a plausibly reasonable miracle
plausible and reasonable because from their point of view their
chanting was efficacious for the bus driver the chanting was even
more efficacious but in a different way because had he known
they were chanting he would have ignored it and killed them all it
was important for him not to have been a buddhist and not to have
been familiar with their chanting practice whereas if the bus driver
was a chanting buddhist just imagine the bus driver as a chanting
buddhist hes chanting theyre chanting theyre all chanting and they
all go down together

now this is an odd memory to unpack its my unpacking the
memory of a story somebody told me is this an experience if its an
experience its an experience of somebodys telling and im not at all
sure that this retelling my retelling is anything like an exact copy of
that other persons telling but whether thats true or not how does it
unpack when i tell it it unrolls as if i had a complete script ahead of
time and im not aware of any script before me i seem to sense it
as i come forward how does a narrative roll out of your mouth

how does it unroll in your mind because it unrolls in your mind
pretty much the same way it unrolls in your mouth like im coming
 to a bridge at some point in every narrative you come to a bridge
whatever kind of bridge it is it has to be crossed something will
 happen at that place and somehow the trigger for me is coming to a
bridge something i might not have thought of but the bridge
 made me think of it
 it was back in the summer of 52 when eisenhower was being
 nominated for the presidency i was working for the forestry
department as a smoke jumper out in idaho and i was hitching back
 home itd been a fine job working in the intoxicating pine forest of
northern idaho just about two miles from the canadian border and
 you made money but i sent most of it back home because there was
nothing to spend it on up there youd work all week and then the guys
would pile into cars and rush off to coeur d'alene to play cards and get
laid by the whores that hung out at the local bar i liked the bar but
 i wasnt turned on by the whores so id go along for a few beers and
play some cards and i didnt spend much money because i wasnt
 losing it at cards and i wasnt spending it on the girls so i had plenty
of money but i got rid of it sending most of it home keeping what
i considered a reasonable amount for the hitch home so i was hitching
my leisurely way back because it was a warm and beautiful summer
 but by the time i got to eastern pennsylvania id almost entirely
 run out of money and i was getting what i hoped would be my last ride
which for some reason or other was pretty hard to get till a guy
 came along in a beaten up old plymouth it was a real wreck that had
almost no brakes and the only way he had to slow down was to gently
 ease on the emergency brake and i would open the door and drag my
foot along the road to help bring the car to a stop the driver didnt
have any money either and somewhere in pennsylvania i gave him my

last couple of bucks for a little bit of gas which took us into new
 jersey where we were starting to run very low he was nursing the
 gas coasting down hills and trying to economize as much as possible
 and as were getting nearer to the george washington bridge i realized i
didnt have enough change for the bridge toll which i remember was
something like a buck and all i have left is fifty cents which as an
old new yorker i knew was just enough for the tunnel but the
 holland tunnel is a couple of miles further south we could get fifty
 cents worth of gas that would get us there but we couldnt pay the
 toll to get through we discuss all this while were coasting down hills
and im dragging my foot to slow down at the bottom and we decide
to go for the tunnel and hope that our gas holds out long enough to
get us there and were watching the gas gauge which i know works
 on a float valve and is never very accurate and were nursing the car
along knowing it can go dead at any minute and we make it to the
 tunnel were finally into the tunnel hoping to get through and
were talking to the car encouraging it come on little car dont go dead
on us now come on little car be a good little car if the car had a
name wed be patting it on the dashboard and whispering in its ear
 come on sybaris come on sybaris dont give out on us now so were
nursing it along and we come out into the light of new york we get
 to tenth avenue and were out of gas

 but the little italian guy the driver hes streetwise he says i
tell you what we do we push her over to some car thats got lots of
gas you lay chickee and tell me if theres any cops coming and ill
 siphon some gas out for us we get out of the car we push the old
wreck over toward a shiny new oldsmobile my friend takes a length
of rubber tubing out of the trunk of the plymouth hes apparently
done this before he unscrews the other cars gas cap inserts the pipe
 sucks the air out and siphons some gas until he figures hes got enough

and then he offers to drive me home but i wave him off because im
kind of glad to see him go and then i realize i dont have the carfare
to get to newkirk avenue because id spent my last money on the tunnel
toll so then i do what lots of new yorkers do i go down into the
subway wait till i hear the train coming leap the turnstile and rush
madly down to the platform and into the train headed for brooklyn

now these stories unrolled smoothly enough from beginning to
end but they all started before the beginning they began at a bridge
and seemed to coalesce around it though i was never aware of that
i was only aware of calling back an experience that came back in the
telling but i dont know how i remember stories though now it
seems like they coalesce around an image maybe it labels them and
they get stored under that label so i call "bridge!" and they come
out like an obedient dog though i very much doubt it but i think i
often recall whole passages of experience from an image a single
salient image and they emerge as stories though not always and
i dont really know how other people remember experiences and whether
they even recall them as stories

the sciences have not been very helpful in the study of memory
when psychologists and neurologists have studied memory theyve
mostly concentrated on simple objects like word lists they might
present you with a handful of words like "solipsism" "civilization"
"orgasm" "cat" and then test to see how many you remember
and you may say them over and over again in your mind and remember
most or even all of them but thats not terribly useful information
because it doesnt tell us much about the way we usually remember
and it tells us nothing about how we remember experiences or stories
though we might combine the words into a sentence like "civilization
permits sufficient solipsism to ignore the cats orgasm" but then weve
turned the word list into part of a story which we might compress

into an image of bishop berkeley serenely contemplating the
moonlight falling on the liffey while two cats are fucking on the river
 bank beside him that would probably give us a better memory of the
word list and do it in a more characteristically human way

　　i think we remember things much better when we narrativize
them which leads me to believe that memory has an organizational
structure much like narrative narrativization or the logic its based
on may be central to memory and narrative experience may itself be
based on the registration of repeated sensorimotor sequences in
volitional action having a form like noticing something starting to
 reach for it almost reaching it and finally reaching it or failing to
reach it

　　but all this is pure speculation and in any case doesnt address the
question of why the same story of the same experience told at
different times can turn out different

　　i was telling the story of how we got across the hudson how we
came to the bridge and turned away and drove to the tunnel and i
remember the little guy who was driving but i had a friend who was
traveling with me on the whole trip home and i dont remember what
happened to him i cant remember what happened to walter walter
and i had come back together we hitched across the whole country
together i remember him sitting next to me in the cab of a truck
 outside bismark but i dont remember him in the car i dont
remember him in that brakeless wreck of a plymouth i dont know if
he was sitting in the back dragging his foot on the other side of the car
out the back door i dont remember him standing by while we were
 siphoning the gas walter has disappeared and now i remember
that he disappeared but i still cant fit him into the experience i didnt
remember him when i was telling the story and now i remember it as
a fact that he was there or i think it was a fact

but somehow the organizational structure left walter out theres
no reason why i should have wanted to leave him out but somehow
it didnt dramatize for me that way there must have been something
about the way the story meant something to me the way my
experience unfolded but this is an experience thats not an accurate
representation of what happened its an adequate representation of
the way i felt it happened

but something is wrong i dont know where to put walter
walters a perfectly fine fellow and i like him theres no reason why
i should want to leave him out but i dont know where he sat in the
story maybe he left somewhere earlier and went home on a bus
but i dont remember that either and somehow hes gone

now this failure suggests something of the reconstructive power
of this kind of memory maybe theres some kind of matrix for the
kind of stories we tell and for the experiences we remember that
may take shape as we experience events again and again and tell stories
about them again and again and the shape our experiences may take
may come from the habits of our telling as the habits of our telling
may take shape from the habits of our seeing and apprehending and
in my case i think they may take shape from a play of contrasts
between certain tonalities

like between the hapless car and the distance we had to traverse
and the funny little guy in his beaten up car who was the only one
willing to give us a hitch while we were being passed by all these other
comfortable people in their expensive big cars on the pennsylvania
turnpike a little italian guy from red hook or bay ridge driving his
brakeless gasless car who probably picked us up for some gas money
and was making a mistake because we didnt have much but he was
almost lovable in his marvelous italian neighborhood smalltime crook
amiability there must have been something that appealed to me in

the contrast between his good nature and his bad character his
competent incompetence and its contrast with the conventional
reality were always presented with

as at the very beginning of the trip back home i remember driving
with one guy who gave us a hitch close to spokane this guy was
driving what in those days was a very fast car a brand new hudson
hornet we get in the car and were cruising along this wide open four
lane highway and it doesnt take long before i notice were sailing past
every car on the road i lean over casually to see the speedometer and
i see were doing 110 miles an hour it doesnt feel like 110 miles an
hour the car is new the road is new and the drive is smooth as silk
still im getting nervous because anything that happens at 110 miles
an hour is going to happen very fast

but the driver is imperturbable hes a freckle faced sandy haired
guy in a plaid summer jacket and an expensive white on white shirt
open at the throat looking like some kind of successful salesman who
turns to me and says why dont you boys keep an eye out for the police
i always get a little concerned when i light a cigarette then he proceeds
to reach into his breast pocket for the pack flips out a cigarette
places it in his mouth puts back the pack and reaches for the lighter
thats when i notice the guy has no arms he has two prosthetic steel
clutching devices hes starting to light the cigarette with one steel
hand on the wheel the other holding the lighter hes driving 110 miles
an hour and handling the car with the confidence of a racing car driver
sure i said well keep an eye out for the cops but you know we really
need to make a phone call and wed appreciate it if youd let us off at the
next exit and i turn around to look at walter his handsome pale face
paler than ever his eyebrows raised in amazement as he looks from
the wheel to the cigarette to the speedometer and back to me shaking his
head and this time walter is with me

endangered

nouns

the other day i looked out the window and saw a bird with a
black head walking upside down along a branch of the honeysuckle
bush outside our dining room it was a familiar bird but strange
 its black cap its queer way of walking head down along the branch were
familiar but its color was strange i had never seen a brown bird
 with a black cap that walked like that not here in southern california
northern san diego but it reminded me of another bird i knew very
well from winters in upstate new york of a different color the
tailored grey of a pair of spats or dress gloves a slightly absurd little
 bird that helped cheer our winters along with the chickadee and a lone
cardinal that used to sit on the leafless shadbush on the other side of
 the brook back in north branch i remembered that bird i said to
myself it was a . . . and then no name came

it was as if
instead of a name there was an empty space the size of a name that
 should have been there

i guess i could have gone to a field guide to find the name but
my field guide was a guide to the birds of california ive been living
here almost twenty years now and it was the new york bird i wanted
 to remember but there was something else also a certain sensual
pleasure mixed with anxiety of tracing a path as if with my finger

around the small empty space in my mind that should have housed
the bird

 because that was what i was experiencing the physical
sensation of tracing a shallow space where the word should have been
and if it was not a pleasure there was a certain almost sensory
satisfaction in running my finger over the space that i felt was just
the right size to house the body of the word i almost said
the bird

 because it was like the archaeological pleasure of finding a
tipped over sarcophagus from which the body it had contained had
simply rolled out or of discovering an inscription carved in the face
of a rock from which one word had been rubbed out

 and while i was enjoying the shape of the scar in my memory my
mind kept stumbling over other memories of winters in north branch
snow piled fifteen feet high along the roadside of the schilburys gerda
and kurt the two german émigrés with their pair of weimaraners
their hopeless foreignness in the bare upstate landscape though this
part of western sullivan county had been german once in the days
when they were cutting down the hemlock trees for the tanbark
industry and had even had a chapter of the bund in pre–second
world war days as names in the phonebook like schadt and ebert and
ellersig still testified

 but gerda and kurt were german jewish though gerda had
become catholic because of the nuns whod sheltered her from the nazis
in their convent and she used to go to mass in the franciscan church
in callicoon while kurt ran for county controller because he wanted to
stem the tide of corruption in western sullivan county but he didnt
have a chance with the local farmers or even in liberty or monticello
and gerda had to stop going to the franciscans because she was shocked
by the violence of their cold war sermons

and i kept seeing the small grey black headed bird whose
name i had forgotten through the kitchen window of the house we
rented from peters the dairy farmer down the road surrounded by
the swarms of images of people and things id forgotten that id known
that seemed in some way related to this one and i remembered
another forgetting that i had experienced in a similar way

the name
of a painter architect a droll horse faced man who had broken with
his friend mondrian over the use of diagonals and the color green
who had introduced dada into holland and designed playful little
geometric houses whose deadpan descendants have cursed european
and american housing developments since the 1960s
 i mentioned this to my son and blaise just shrugged and said "i
bet you can name all the charger receivers"

which i thought i could
so i said charlie joiner and wes chandler and bobby duckworth who
was still with the chargers then and those were the wide receivers
and i started on the tight ends there were three of them and i got
through eric sievers and pete holohan and i came to the greatly gifted
one the giant black one with the face of a petulant child who i
remembered seeing in a game once with miami three times come
limping off the field nearly destroyed by collisions that might have
hospitalized an ordinary player and i remember this shot of him on
the sidelines between hits slumping exhausted and helmetless his
face drained of everything but weariness and pain like some roman
gladiator and i remember seeing him return three times to a struggle
that only his pride and nasty character lent an illusion of dignity and
tragic seriousness beyond the ridiculous game
 and it happened again i forgot his name

"blaise" i said "i cant remember his name" and he asked
"should i tell you"

"no" i said "let me try to remember it"

"kenneth maybe no it isnt kenneth its kenneth i think
kenneth washington no booker? booker t washington kenneth
washington no kennel kellen kellen winslow"

and so i came round to it knowing i knew it all the time which
means what?

that i could come around to it that i could arrive at it
that i knew what it wasnt and if i tried long enough and hard
enough i could find a way of getting to it the way i used to find my
way as a child to the ancient capital of egypt by passing through the
names of laundry soaps

rinso lux luxor thebes

by way of the
sound poetry of the language which is my language our language
in a way that talking will not often show or maybe theres something
in back of language that stands behind it and makes it possible not to
remember but to remember what you forget even when you cant
remember it which is like coming to stand before a place to which
memory may or may not be able to arrive

the way my mother in law
went looking for a lost story she used to hold up before her life

it
concerned her own mother back in poland then and she told it many
times

"my mother was a tiny little woman but she was a strong
woman a businesswoman my father was a scholar and he had no
time for such things" this was the central theme and jeanette had

taken it to heart because throughout her life jeanette had thrown
herself into business after business small hotels then larger ones
grandly conceived family enterprises that were almost always just
beyond her reach so we heard this story many times

"my mother was a tiny little woman but she was very strong
and she ran the local mill where the peasants brought their grain
and one week she neglected to get enough cash to pay off all the
peasants so she had to give out notes to the ones that came in last
and most of them grumbled a bit so she would make a little joke
and they would laugh and take them because they knew her and knew
that she was good for it but one peasant a huge man and very
drunk got very loud and insisted on receiving cash

"but my mother just looked at him and said 'what do you think
im going to give rubles to a drunken peasant youll just drink it up or
lose it in a ditch or worse you go home and send your wife and ill
give her the money' but the peasant roared that no woman was
going to lead him around by the nose and he would go down to the
bank with her to get the money now

"but my mother said 'you think im going to take you to the
bank like this theyll take one look at you and chase you out
besides the bank is closed'

"but the peasant swore that nobody was going to chase him out
even if they were closed and he held up a giant fist and demanded
cash or else and the little woman looking up at the fist above her
head cooly turned her back on him and happened to catch sight of her
tiny nine year old son watching big eyed from the corner 'samuel'
she said 'go get a stick and show this gentleman out'"

which punch
line in the authorized version in its absolute absurdity delivered
with perfect sangfroid so tickled everyone that even the drunken

peasant couldnt keep from laughing so hard he had to sit down and cry

but in the last few years my mother in law has been losing hold of the lines that held her to her life which has been slipping away with fewer and fewer lines to hold to shes been living in a resident hotel filled with older people whose lines are similarly slipping and with whom it doesnt always so much matter but from time to time when we come to visit she reaches out of habit for one of the stories to which her life was moored and she happened to reach for this one

"my mother was a tiny little woman but very strong. . . ." and she went through her story to the angry peasant and how her mother looked up at the giant fist and cooly turned around then she reached for the punch line

but jeanettes little brother was hopelessly gone and jeanette waited just a moment and replaced him with manya their old peasant housekeeper who wasnt frail enough to carry off the joke so my mother in law stopped and started over

"my mother was a tiny little woman . . ." and she went through the whole story again and as she drew near the ending this time the old housekeeper was gone so jeanette replaced manya with her scholar father which clearly would not suffice

three times jeanette made her way around the story of her mother and the drunken peasant and each time she circled the story the actors changed they became in turn the maid her father and her own husband and three times she looked for the line that her mother now delivered imperfectly to the altered personnel and each time she came to the end of the line she paused and began again but the third and last time she arrived at the line she simply stopped and waited and im not sure how long she was prepared to wait

designer victoria kuskowski

compositor integrated composition systems

text aldus roman

display gotham book

printer + binder thomson-shore